EXTREME WORLDS

the complete guide to drawing and painting sci-fi art

EXTREME WORLDS

the complete guide to drawing and painting sci-fi art

Francis Tsai

To the '3 Ms': S. Makoto, B. Masato and N. Masaki
and their skilled wranglers David and Marice.

751.4
TSA

ACKNOWLEDGMENTS
Many thanks to the crew at David & Charles Publishers
— Freya Dangerfield, Verity Muir, Jodie Lystor and
Martin Smith for their hard work. Much gratitude to
Ame Verso for her professionalism, thoroughness and
eye for detail. Much love and appreciation to my wife
Linda for her patience and support, and to my parents
Yung-mei and Sawako, two of my biggest fans.

A DAVID & CHARLES BOOK
Copyright © David & Charles Limited 2009

David & Charles is an F+W Media, Inc. company
4700 East Galbraith Road
Cincinnati, OH 45236

First published in the UK and US in 2009

Text and illustrations copyright © Francis Tsai 2009

Francis Tsai has asserted his right to be identified as
author of this work in accordance with the Copyright,
Designs and Patents Act, 1988.

A catalogue record for this book is available from the
British Library.

ISBN-13: 978-1-60061-341-8 paperback
ISBN-10: 1-60061-341-1 paperback

Printed in China by SNP Leefung
for David & Charles
Brunel House Newton Abbot Devon

Senior Commissioning Editor: Freya Dangerfield
Editorial Manager: Emily Pitcher
Editor: Verity Muir
Project Editor: Ame Verso
Senior Designer: Jodie Lystor
Production Controller: Beverley Richardson

Visit our website at www.davidandcharles.co.uk

David & Charles books are available from all good
bookshops; alternatively you can contact our Orderline
on 0870 9908222 or write to us at FREEPOST EX2 110,
D&C Direct, Newton Abbot, TQ12 4ZZ (no stamp
required UK only); US customers call 800-289-0963 and
Canadian customers call 800-840-5220.

contents

> The large, armoured character was wearing a skull-like helmet and wielding what looked like a sword with a blade made of light. His opponent, smaller and more agile looking, possessed his own laser sword and was about to engage the larger character in battle. The pair appeared to be facing off in a dimly lit corridor constructed of various high-tech materials, designed in a style that clearly indicated a setting somewhere other than the here and now.

TESSERACT 9
A soldier patrols an atmospheric processing refinery on a distant alien planet.

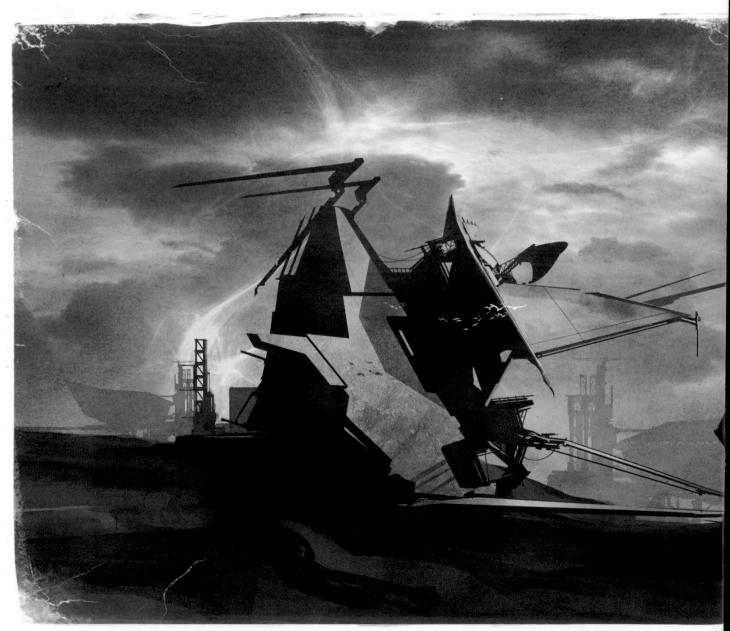

The image I am describing was one of conceptual artist Ralph McQuarrie's production paintings for the movie *Star Wars*, depicting early versions of the film's central characters. As a child, this image was one of the first that made me appreciate the power of science-fiction design and illustration. Both characters were clothed in armour and equipped with gear that was clearly technologically advanced. The sense of conflict was apparent but the details of the characters and environment indicated something intriguingly unfamiliar. To me, the painting combined high-tech, advanced science with a sense of raw aggression and tension, and instantly ignited my imagination.

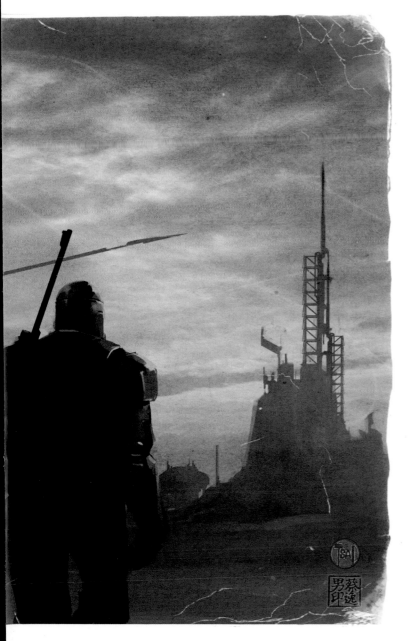

DEFINITIONS AND A BRIEF HISTORY

What exactly is science fiction? Purists would argue that *Star Wars* is an example of science fantasy rather than science fiction. There have been many different definitions of the term science fiction, but one commonly agreed-on component is the emphasis (at least to a token degree) on the 'science' element. Depending on how you look at it, science fiction has been around ever since human beings began constructing elaborate mythologies to explain the world around them and how it might have come to be created.

The modern idea of science had an important influence on Western literature of the 18th and 19th centuries. Jonathan Swift's *Gulliver's Travels*, Mary Shelley's *Frankenstein* and the works of Jules Verne could all be considered examples of early modern science fiction. However, what we recognize as science fiction today came into being in the early 20th century, mainly in the form of pulp novels and anthology magazines. The stories that appeared in these publications were an evolution of the earlier science-influenced literature and incorporated new discoveries and concepts from the real world. The illustrations that accompanied these stories were usually fairly lurid and sensationalistic, but the better examples had exciting and inspirational qualities, just like Ralph McQuarrie's painting that enthused me as a boy.

CURRENT AND FUTURE TRENDS

In recent years, science and technology have evolved at a rapid rate and science fiction has followed suit by splintering into many different sub-genres – for example, military science fiction, space opera, time travel, cyberpunk and steampunk. These, and many other sub-genres of science fiction, look at specific aspects of science and technology and how they might affect us.

The imagery of science fiction has developed similarly, especially with the advent of computer technology – both 2D and 3D – to help artists realize their visions for book covers, comics and designs for video games and films. The different kinds of entertainment media have increasingly come to cross-pollinate each other, with books spawning films, films giving rise to games based on the characters and storylines, and comics influencing and being influenced by video games and movies.

In terms of an artist's toolset for creating science-fiction imagery, digital painting programs continue to advance, providing a way for artists to create artwork that is almost indistinguishable from that created using traditional media. Beyond emulating familiar media, as they continue to evolve, digital tools enable artists to create imagery that would be difficult or exceedingly time-consuming to accomplish using traditional media.

THE ROAD AHEAD ...

Science and technology seem to be advancing at an increasingly accelerated rate. Everyday consumer electronics products such as mobile phones with Bluetooth headsets, as well as research currently underway in the areas of genetics, robotics and nanotechnology, were the stuff of science fiction not too long ago. Taking inspiration from these trends and using the tools and techniques described in this book will enable you to begin creating the next generation of science-fiction art.

how to use this book

Despite the giant leap in the recent evolution of science-fiction art, one thing that has remained constant is the need for fundamental illustration skills. A science-fiction artist is tasked with creating images that exist only in his or her imagination, perhaps showing aliens or technology that has never been seen before. An artist must be able to communicate with the viewer using a visual language (encompassing lighting, perspective, colour theory and so on) that they have a shared understanding of, in order for the vision to come across effectively. The fewer of these 'rules' that are used in visual communication, the more difficult it is for the viewer to understand what they are looking at.

To this end, this book works chronologically, starting with the basic concepts of tools, shapes, perspective, colour, inspiration and reference and the techniques of drawing and painting both traditionally and digitally. It then moves on to reveal, in step-by-step detail, how nine fully rendered science-fiction artworks can be achieved with relative ease. The final part of the book explores the concept of space opera, building up each individual element in turn to create an intriguing storyline encapsulated in a eye-catching poster design.

The demonstrations in this book have been designed so that you can use either digital or traditional media. In some cases, however, the process will differ slightly depending on which method you use. When necessary, specific instructions are provided for both methods.

As well as providing a rich source of inspiration, the demonstrations and notes in this book will show how you can use time-tested skills, concepts and workflow patterns to bring your science-fiction visions to life.

Colour theory is a fundamental concept that must be grasped to create effective science-fiction art.

An understanding of values and how they are used to indicate form and light is of prime importance in creating convincing illustrations.

You don't need to reinvent the wheel – using reference helps you avoid unnecessary work and visual errors.

Not everything you draw needs to be a polished illustration; sketching is a great way to practise and flesh out half-formed ideas and concepts.

'Greeble' is a term used by industrial designers and illustrators to generally describe the detailed, complex-looking mechanical elements that are used to add visual interest and complexity. The form language of greebles borrows heavily from familiar sources such as automobile engines, modern weapons, electronic components, plumbing and other highly engineered, complex utilitarian objects. Creating science-fiction illustrations will undoubtedly require a large vocabulary of greebles, so maintaining a collection of inspirational images of these types of objects can be a valuable resource. The greebly details in the engine in this fighter ship borrow some visual elements from the engine bay of a V8 Mustang.

Phase 7: Basic colour block-in

Start blocking in the colour scheme, filling the background with a blue-grey colour and the ship with a lighter warm medium grey. Give the canopy a darker warm grey. The colours of the ship are chosen to portray an industrial metal primer colour, emphasising its functional nature and also providing a nice temperature contrast with the background. Use a round, hard-edged brush to fill in the flat areas of colour. If working digitally remember that using the Lasso and Paint Bucket tools to fill large areas can save time and effort (see Tip page 60).

Phase 5: Final line work

On a new piece of tracing or parchment paper laid over the sketch, lay out the final line work with an ink pen. Try to avoid using a straightedge for this stage: slight irregularities will preserve some of the hand-drawn quality of the line art. However an ellipse template can be useful for any circular parts of the hull and engines (see Tip page 73). In this phase last-minute details such as bolts, warning graphics, vent intakes and other greebles (see Tip above) can be added.

Phase 6: Preparation for painting

If you are working digitally scan the final ink drawing into the computer and open it in your painting software. Use the Levels tool to clean up the drawing and replace the paper colour with a white background in preparation for colouring and rendering (see page 16). If you prefer to work traditionally transfer your line drawing to the final media using a light box.

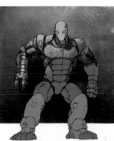

Add a different colour to sections of the ship to distinguish the functions of the individual parts. This will help the reader understand the design more easily.

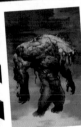
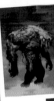

Phase 8: Function differentiation

Use a dark, neutral grey to call out the mechanical and utility areas such as engines and weapons and various exposed greebles. Leave the warm grey from the previous phase to represent hull plating and fairings. At this stage you are still concerned with blocking in only the flat colours.

In the Demos section, some common kinds of illustrations are broken down into step-by-step sequences; you're encouraged to follow the process but explore your own ideas in terms of forms, shape and colour.

Phase 10: Rendering continues

Carry on rendering of the lower half of the body, fading the colour to a darker value to maintain the gradient from light to dark as the wheel's tyre stands down the alien's body. Fade out the legs to indicate that it is starting in mist near the ground by bringing some of the blue colour from the background up on to the lower legs. Create a gradient between the mist colour and the dark green shadow of the alien's lower legs, blurring the boundary between them.

Phase 12: Final image

Add a hint of complementary colour to the face with a very fine brush to help draw attention to the focal point. Subtle orange/brown shades create a feeling of material change between the heat structures and the rest of the face. Eyes are usually rendered as glossy highly reflective surfaces and mammalian eyes tend to be moist. Rendering the eyes will add to the sense of strangeness. To make the effect of an old magazine colour add some distressing to the edges of the image. Layer a very translucent wash of sepia colour over the image, mellowing the effect somewhat and adding a unifying colour influence to the whole illustration. The final effect is one of a vintage pulp 1950s characterised by his massive bulk, spider-like eyes and the eerie mist...run for your life!

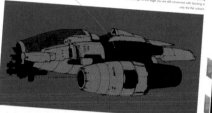

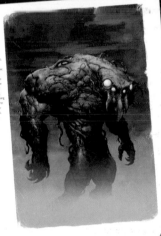

Phase 9: Rendering and tweaking

Continue the detail pass, working across each area of the body in turn. Try to remain aware of the image as a whole and not get too focused on one spot of detail. If necessary major adjustments can be made, for example, increasing the width of his right arm, to exaggerate its misshapen quality. Pay attention to the face – the focal point of the illustration. Refine the graphic shape of the eyes and reserve one particular yellow colour then. Some hints of that yellow can appear in other areas to unify the image, but these should be subservient to the intensity of the colour in the eyes.

Suggest strange gases and particles in the air by painting in some light, splattery brushmarks around the base of the alien.

Phase 11: Atmosphere

Add more mist to the foreground, making the transition between the alien's legs and the fog even more gradual. Add a layer of fairly bright, warm yellowish-green on top, implying a thick, humid atmosphere between the alien and the viewer, starting out fully opaque and making it gradually more transparent as it climbs up the alien's body. Some of the detail will be lost but the silhouette should still be readable.

Aliens and monsters are a mainstay of science fiction. In this demo you will learn how to create believable alien biology.

Phase 9: Rendering begins

Once your colours are blocked in you can start rendering – the main thing to keep in mind at this stage are the lighting direction and the nature of the materials. The light source is above and to the left, and the forms will react to this in different ways. The round forms will have highlights that gradually fade to darker values as they turn away from the light source. The rectangular forms will have sides facing the light and sides that are in shadow, and will therefore have more distinct edges between different values. Lay in the smooth transitions on the curved, cylindrical shapes using a dark grey-blue colour and light blue-white for highlights along the centre of the cylindrical forms. Paint the more defined transitions with hard-edged brushes. Start playing around with textures such as scratches, dents and dirt or oil stains using a small-diameter brush. Rather than using white, use a light bluish-grey to indicate the shade of the metal surface underneath.

Phase 10: Further detailing

At this stage you should mainly be concerned with details, but it's a good idea to zoom out frequently and study your image as a whole. It's easy to get too lost in detail and risk spoiling the overall colour/value design of the image. As you work on the painting, look at the entire image regularly to make sure the shading/highlight/material rendering is not calling undue attention to any one area. Continue to work on the colour rendering using the strategy outlined in the previous phase. Be consistent in the ways painted surfaces Vs bare metal surfaces, cylindrical Vs rectangular shapes, and flat panels Vs mechanical details (greebles) are rendered.

Phase 11: Final image

I realise the illustration by indicating spots of cast shadow based on the direction of the main light source. Here, the main light source is above and to the left of the character. The right side (his left) is in shadow, and you can see shadows being cast on the leg and upper-rule forearm. The final image shows a character that is obviously mechanical and robotic in nature, but whose body design draws a rhythm and fluidity that is based on the human figure. With heavy-duty construction and sturdy proportions, he is perfectly designed for his duty as a combat robot and would be a tough opponent in battle.

Robots have the potential for helping or harming human beings. This demo shows you how to draw and paint a heavy-duty combat robot.

BASIC CONCEPTS

THE TOOLS AND TECHNIQUES OF VISUAL COMMUNICATION

Although science-fiction art involves creating fantastic, exaggerated imagery, the techniques required are essentially the same as those used for creating more traditional art genres, such as still life or landscape paintings. Science-fiction illustrators have used tools such as pencils and paper, watercolours and board, and oils and canvas for almost as long as science fiction has been around. Computers and digital painting and drawing programs have become advanced and versatile enough to provide viable alternatives to the more traditional artist's tools, but they probably won't ever completely replace traditional media.

In addition to the physical tools of the trade, the science-fiction illustrator will also benefit from an understanding of fundamental concepts such as shape, perspective and colour. These are areas of knowledge that are independent of the tools you use to create an image and are vital if you want to have any success at communicating your ideas to your audience. This chapter looks at the tools, theories and techniques you need to master for success in science-fiction art.

Creating an illustration is, at its heart, the act of putting marks down on a surface for others to see, whether those marks are on paper or canvas, or more recently, on a computer screen. For an artist interested in using what have come to be called 'traditional' tools (ie not using a computer), there are many different media you can use to make your mark.

Traditional drawing and painting tools offer the beginner or amateur artist considerable flexibility and rendering options in return for ease of maintenance and minimal expense. The example illustrations shown on these pages were created using pencils, acrylics and watercolours. However, one of the joys of working with traditional tools is that the different media can be combined in any way you like.

PENCILS

The most basic drawing tool that almost everyone has access to and is probably most familiar with is a pencil. Pencils range from the simple wood No.2 variety used in primary schools to specialized mechanical versions. Mechanical pencils offer numerous advantages, such as varying lead hardnesses and widths. Lead hardness ranges from 9B, the softest, to 9H, the hardest.

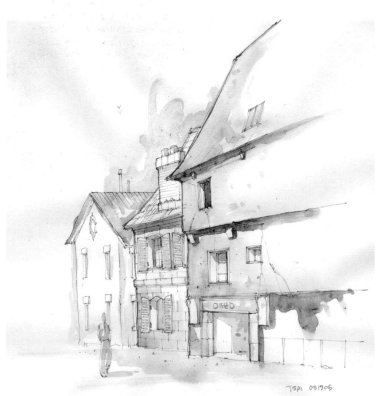

Softer leads provide darker, richer tones but can be messy to use; harder leads allow more precise line work, but it can be difficult to achieve a nice range of values. F and HB leads are of medium hardness at the centre of the range.

OTHER DRAWING TOOLS

Professional artists also often use pen and ink and markers for drawing. Ink pens range from simple felt-tip and gel pens like those found in office supply shops, to technical drafting pens that use interchangeable tips and require a high degree of maintenance. Pigment liners, which contain waterproof or solvent-proof ink, are less likely to bleed and run. Grey and coloured markers are useful for preliminary and development sketches, to indicate value and colour quickly. Although finished illustrations are often rendered using paints, some artists are able to create highly polished, finished renderings using markers alone.

SEMI-TRANSPARENT PAINTING MEDIA

When you want to lay down colour but allow the line drawing underneath to show through, you need to use a water-based paint (watercolour or diluted acrylics) or coloured pencils. Watercolour is known for its luminous, spontaneous look. It can be a very evocative medium but is quite unforgiving – revisions are very difficult to do with watercolour, something to keep in mind when using it for commercial assignments. Coloured pencils, such as those manufactured by Prismacolor, provide an artist with a high degree of control, and can be blended to achieve paint-like effects using water or a solvent.

OPAQUE PAINTING MEDIA

For more opaque paint effects, media such as gouache, acrylics and oils are widely used. Gouache and acrylics are water-based, meaning that the pigments are manipulated using water. In oil paints, the pigments are bound with oils such as linseed oil, and are diluted using various thinners and solvents. Oil paints are slower to dry than water-based paints and allow a little more flexibility in mixing and blending.

BRUSHES

A good set of brushes is vital for the traditional artist. Brushes can be made of natural or synthetic materials – nylon brushes are typically used with acrylic paint while sable, camel hair or stiff hog bristle brushes are often used with watercolour or oil paints. Brush sizes range from 10/0 (smallest) to 30 (largest), and come in a variety of shapes, such as round, flat, filbert (flat with a rounded end) and fan (shaped like an open oriental fan). Large-diameter flat brushes like the fan and filbert are useful for covering large areas, while small-diameter round brushes are used for line work and details.

STREET SCENE
This sketch was drawn with pencil in a small sketchbook then rendered with a very dilute wash of burnt sienna acrylic paint.

DRAWING TOOLS

An assortment of drawing tools that a professional artist might use.

Mechanical pencil – a large barrel and a padded gel area near the base make it comfortable to hold for long periods of time. This is one of my favourite tools, using a 0.5 HB lead.

Pigment liner – a number of different companies make variations of this pen, which uses waterproof black ink.

Electric eraser – used in areas of high detail where only certain parts need erasing. They come in a range of shapes and sizes, from smaller battery-operated ones like this, to larger, plug-in varieties.

Kneaded eraser – made from a putty-like material that can be moulded into different shapes, such as a point for detailed work.

White plastic eraser – a nice, clean eraser for large areas.

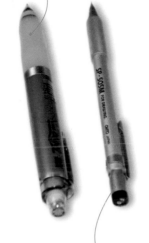
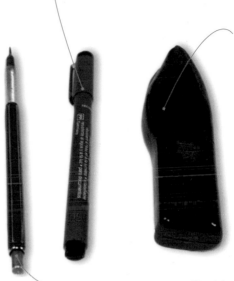

Mechanical pencil – constructed of aluminium, this also uses a 0.5-size lead.

Clutch lead holder – typically used by architects, engineers and some comic book artists. The lead is thicker than in mechanical pencils and is sharpened with a specialized sharpener. This pencil allows more variation in line weight.

SUMMER ARMOUR

A character sketch drawn with pencil and rendered in watercolour.

DRAWING AND PAINTING SURFACES

What you choose to draw or paint on can consist of almost anything that will hold pigment. After all, artists first began by painting on cave walls and some contemporary artists paint on wood, ceramic tiles, metal siding and even cars.

For the purposes of commercial illustration, it's preferable to use a surface that allows easy reproduction. Drawing papers, illustration boards and stretched canvases comprise the major types of drawing and painting surface that you would use as an illustrator. Bristol paper is a very common medium; it can be used on both sides and comes in smooth or textured finishes. Illustration boards are heavier and also come in smooth (hot press) or textured (cold press) varieties. These boards have only one working surface but can take a wide variety of media, from pencils to paints.

Artists using oil paint usually use a canvas or linen surface stretched across a wood frame. The canvas needs to be treated with gesso, a material that acts as a primer and allows the paint to adhere to the surface of the canvas.

digital tools

The term 'digital media' refers collectively to hardware and software that allows an artist to create imagery on a computer. Digital tools usually cost more than their traditional 'analogue' counterparts, but they offer considerable advantages in speed and convenience.

DIGITAL HARDWARE

The foundation of a digital artist's studio starts with a computer. Creating artwork on the computer can be very demanding on the hardware, so always buy the best you can afford. A fast processor and plenty of RAM are the main components. My advice would be to purchase the second or third fastest option currently available, as you will get the benefit of almost state-of-the-art hardware without paying the premium for the latest cutting-edge model. Brand-new machines become second or third best within a matter of months anyway.

The computer monitor is another area you shouldn't skimp on. Accuracy in terms of colour reproduction is of paramount importance to an artist. A large, high-resolution monitor will allow you to see more of your work on screen at once, and can help prevent eyestrain.

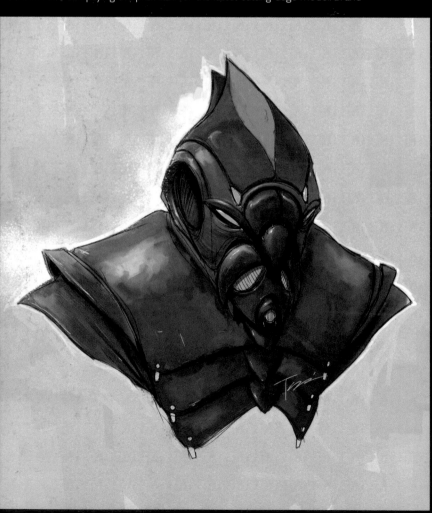

PAINTING SOFTWARE

Adobe Photoshop and Corel Painter are the two primary, high-end digital painting programs used by professional artists. These programs provide the artist with a huge variety of tools. Photoshop is used by many different graphics professionals, including photographers, web designers and graphic designers, as well as illustrators. My experience has been that I typically only use a fraction of the available tools in Photoshop. Painter is much more specialized and is geared towards digital painters. It is well known for its ability to accurately reproduce the effects and qualities of many different kinds of traditional media.

There are a number of more affordable options, however. One of my favourites is an inexpensive program called Art Rage from Ambient Design (www.ambientdesign.com). Art Rage is similar to Painter in its ability to mimic traditional media. A Japanese program called OpenCanvas (www.portalgraphics.net/en/) is another good, fairly cheap alternative to Photoshop. Adobe also makes a more economical version of Photoshop called Elements, which has many of the same tools as the higher-end version.

DIGITAL MIMICRY
This character sketch was created in Art Rage, using the paintbrush, palette knife and chalk tools. The brushes in this program replicate traditional media more closely than those in Photoshop.

3D MODELLING PROGRAMS

In addition to painting software, another tool that can be extremely useful to the illustrator is a 3D modelling program. There are many options, and software can range in price from free to extremely expensive. It is still important to understand the concepts and principles of creating an accurate perspective drawing, but using 3D modelling programs such as Google SketchUp, Maya or 3DStudio Max can save a lot of time. This type of software also provides the ability to try out different camera angles, adjusting the perspective in the scene much more quickly and easily than setting up a constructed perspective drawing.

For an illustrator, 3D modelling programs can provide a simple and effective way to portray complex geometry accurately. A vehicle or architectural design can be explored and studied from different viewpoints, which allows an artist to have a better understanding of its three-dimensional form. Additionally, creating and lighting a simple 3D model can provide a basis for a more painterly 2D illustration.

Photorealistic 3D modelling, involving lighting and textures, is a whole other area of creating imagery, and there are scores of books written on the subject.

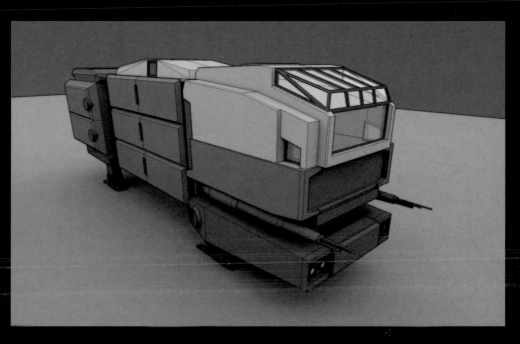

SPACESHIP MODEL
A 3D model of a generic freighter ship based on a design sketch. Shapes and proportions can be explored in the 3D program and the model can be rotated and viewed from different angles to check the design.

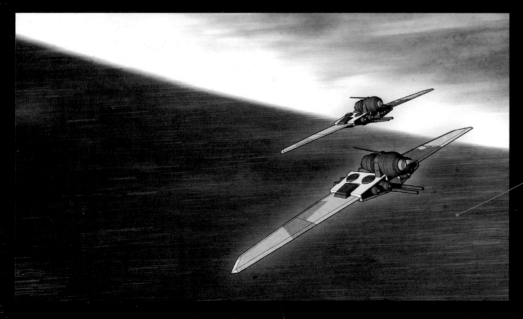

There are various different 3D modelling programs on the market, but my favourite is Google SketchUp for its user-friendly interface. These spacecraft were created in SketchUp in a matter of minutes.

2D/3D COMPOSITE IMAGE
This illustration combines 3D models (the flying scout ships) and 2D painting (the planet and star field) to create a composite image with depth and drama.

DIGITAL VS TRADITIONAL

For as long as commercial illustration has been a recognized occupation, illustration work has been created using traditional media such as pencils, paper and paint. In the last decade or so, the technology of creating artwork using 2D painting programs and 3D modelling programs has advanced to the point that they offer viable alternatives to traditional media, along with some significant advantages. At the same time, there are certain qualities of traditional or analogue media that digital tools can't quite capture just yet.

Let's look at line drawings as an example. Creating a line drawing is one area where there remains a perceptible difference between digital painting programs and normal pencil and paper. Drawing requires a very fine degree of motor control and hand–eye coordination. The immediate feedback that happens in the contact of pencil to paper represents a threshold that digital tools have yet to cross, although this gap is closing quickly.

The development of touch-sensitive computer monitors, which allow an artist to draw directly on the screen, has gone a long way towards providing that sense of immediate tactile feedback. The most significant technological advance prior to that was the development of the digital drawing tablet, which represented a huge step forwards in allowing digital drawing and painting to evolve into a viable alternative to traditional techniques. Because of the way drawing tablets are set up, artists draw on one surface and look at another, which is a very different experience to drawing with an analogue tool. There is a new layer introduced between the artist's hand and eye, and it takes a while

to become accustomed to drawing in this way. In my own experience, I've come to see this as an advantage – my drawing hand is never in the way of what I'm trying to see!

COMBINING DIGITAL AND TRADITIONAL

The flexibility of digital media is such that an illustrator can combine the best attributes of both digital and analogue media. Importing a hand-drawn image into a digital painting program enables its handmade quality to be preserved, while allowing the artist to benefit from the advantages of digital tools.

Additionally, once an analogue image has been imported, it can be adjusted and cleaned up – stray marks can be erased, proportions can be changed (to a certain extent), and overall contrast can be improved. The following images show how a pencil drawing can be scanned into Photoshop and adjusted using some of the built-in tools to create a clean, high-contrast black-and-white drawing.

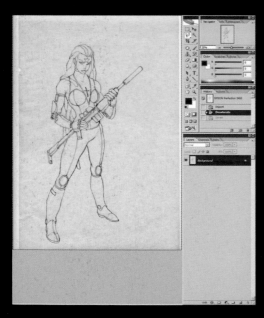

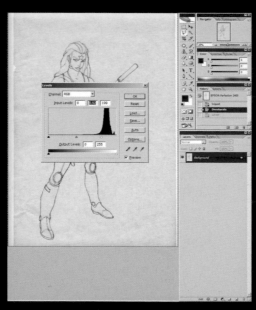

INITIAL SCAN
The raw image has been scanned into Photoshop — the noise and texture from the paper can be seen in the background.

CONTROLLING TONAL RANGE
The Levels adjustment in Photoshop allows you to affect the amount and distribution of light and dark tones in your image. The large black peak seen in the 'histogram' graph represents the grey in the image; by moving the right-hand slider to the left of the peak, the grey in the image can be removed.

CLEANED UP
After the Levels adjustment has been applied, the canvas colour is left a clean white.

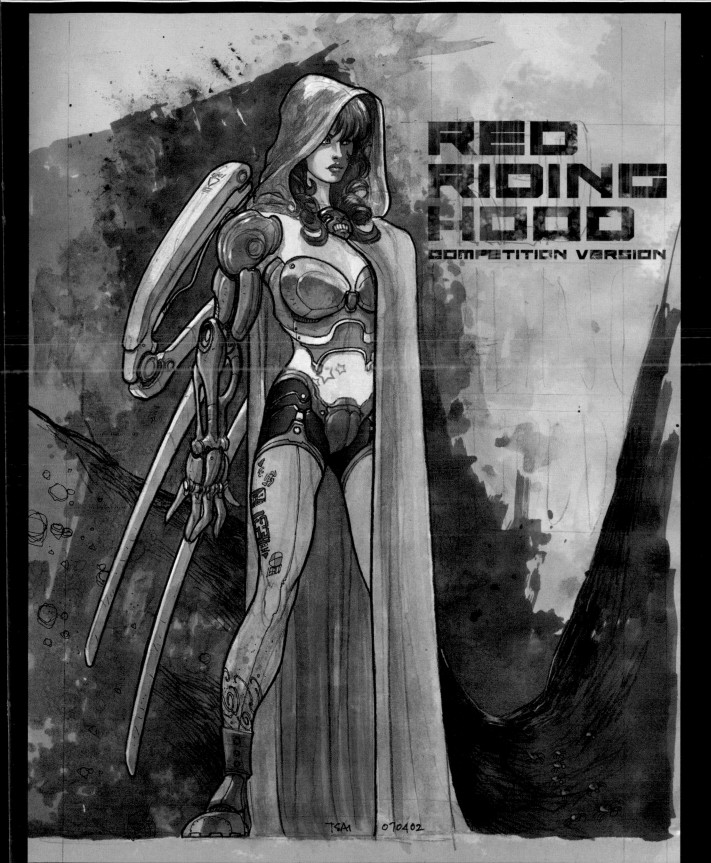

shapes

Any object, whether it is a vehicle, a building, a weapon or even a character, can be simplified into a collection of one or more simple shapes. These shapes are known as 'geometric primitives', with the term primitive referring to the fact that an object has been simplified to its most basic form. This section reveals how to use these shapes to create a wealth of different science-fiction subjects for use in your images.

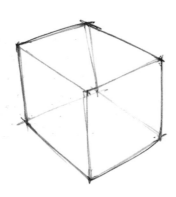

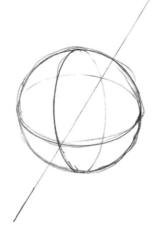

BASIC GEOMETRY

The cube, cylinder and sphere are the three basic geometric forms, or 'primitives', that make up almost every object you can think of. These primitives can then be tweaked, adding a taper, elongating or otherwise altering the shape slightly to produce a more diverse range of forms.

The cube, cylinder and sphere are the building blocks of any object.

Altering the basic forms slightly, such as adding a taper to one end, gives the shape an element of liveliness and personality, and allows it to be used for a much wider range of illustrative purposes.

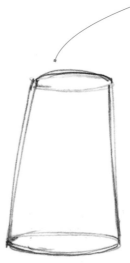

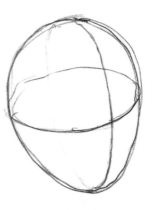

OBJECTS CREATED FROM A SINGLE SHAPE OR INTERSECTING FORMS

Some simple objects can be described using just **one basic shape**; for example, a wheel is a very short cylinder turned on its side, and an LCD computer monitor is simply a flattened box. However, most objects can be thought of as consisting of **a number of geometric primitives intersecting with each other**. For example, an ordinary passenger automobile can be seen as a long rectangular box forming the base and a smaller box on top containing the 'greenhouse' or glass area. In fact, among industrial designers this style of vehicle is sometimes referred to as a 'two box design'.

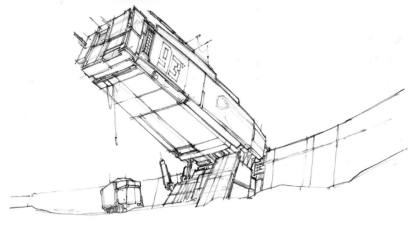

CREATING OBJECTS FROM SHAPES

The armoured personnel carrier vehicle on the left of this image was created from a single box-shape, although there are numerous secondary shapes in the armour plating and flattened cylinders for the wheels. The yellow fighter craft on the right consists of several primitives intersecting each other at varying angles.

USING GEOMETRIC PRIMITIVES

This outpost, created from spare parts and recycled shipping containers, consists mainly of two box-like shapes; one forms the base connected to the wall running through the scene, and a second, larger box is set at an angle on top of the base. Details can be added to the basic shapes by indicating layered plates and patchwork repairs, along with sensors and instruments jutting out from the main form.

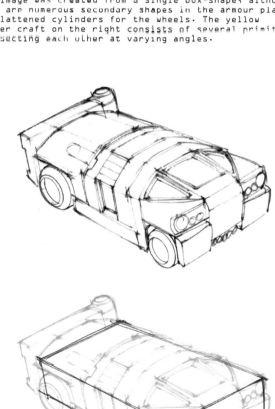

A single box can be the starting point for many science-fiction vehicle designs.

Several boxes drawn at intersecting angles creates an exciting and dynamic spacecraft.

FIGURES AS PRIMITIVES

Living creatures can also be seen in terms of their basic geometric forms, a collection of all three primitives – cubes, cylinders and spheres. In humans, the head can be represented by **an elongated sphere or egg-shape**. The torso, arms and legs are described by **cylinders** with varying degrees of elongation and tapering. Hands and feet are simple **box shapes**. To create robot or alien figures you can **take a departure** from these shapes going in any direction you like – for example, you could use a perfect sphere or a long cylinder for a robot's head rather than a egg shape. For an alien, you might want to give him three heads based on cubes.

When drawing figures, human or otherwise, the first stage in their creation should be **a gesture line** to establish the **basic posture and attitude** of the figure. This is then built up with geometry to flesh out the figure – for more advice on this process, turn to the step-by-step demonstrations in the Characters chapter, pages 44–63.

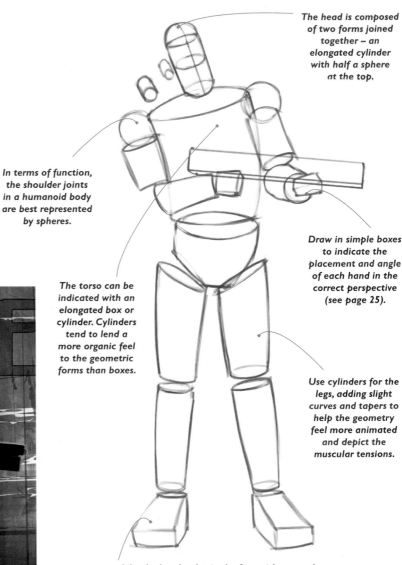

The head is composed of two forms joined together – an elongated cylinder with half a sphere at the top.

In terms of function, the shoulder joints in a humanoid body are best represented by spheres.

Draw in simple boxes to indicate the placement and angle of each hand in the correct perspective (see page 25).

The torso can be indicated with an elongated box or cylinder. Cylinders tend to lend a more organic feel to the geometric forms than boxes.

Use cylinders for the legs, adding slight curves and tapers to help the geometry feel more animated and depict the muscular tensions.

Like the hands, plot in the feet with tapered boxes to give yourself a guide to placing the feet on the ground in the required perspective.

BUILDING A FIGURE FROM GEOMETRIC FORMS

This cyborg soldier began life as a collection of geometric shapes. He is basically humanoid in form, but his head is much more elongated than a normal human's. The cylinders forming his arms and legs are tapered slightly, and also have a very slight arc through the length of the shapes.

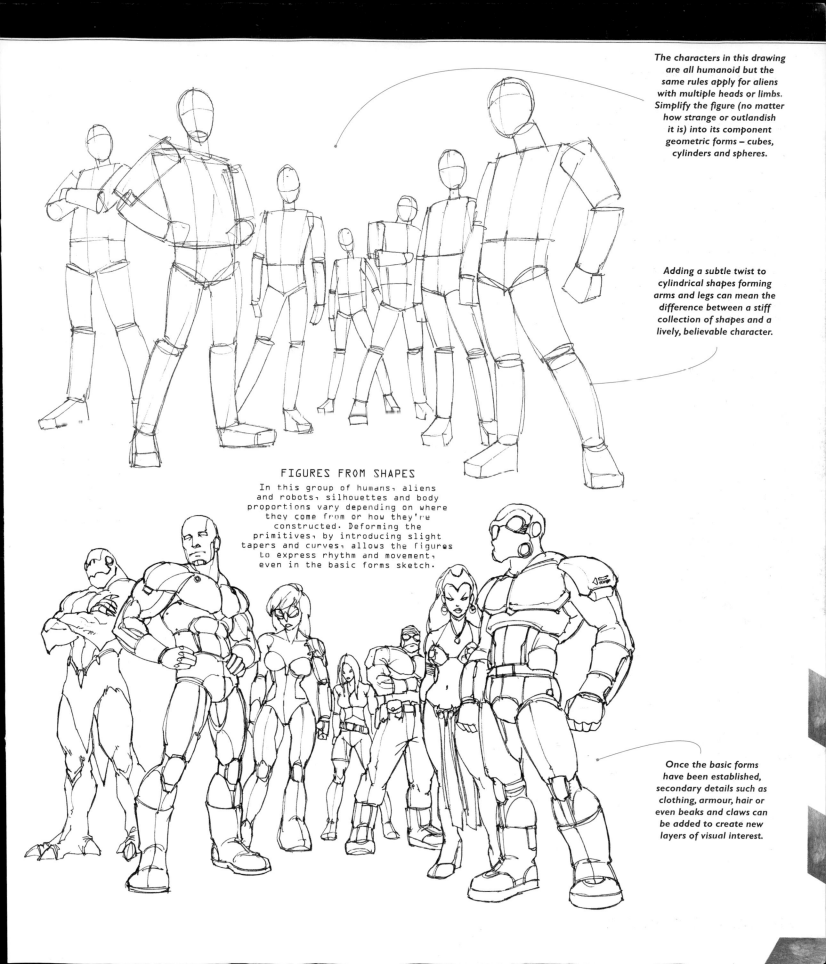

The characters in this drawing are all humanoid but the same rules apply for aliens with multiple heads or limbs. Simplify the figure (no matter how strange or outlandish it is) into its component geometric forms – cubes, cylinders and spheres.

Adding a subtle twist to cylindrical shapes forming arms and legs can mean the difference between a stiff collection of shapes and a lively, believable character.

FIGURES FROM SHAPES

In this group of humans, aliens and robots, silhouettes and body proportions vary depending on where they come from or how they're constructed. Deforming the primitives, by introducing slight tapers and curves, allows the figures to express rhythm and movement, even in the basic forms sketch.

Once the basic forms have been established, secondary details such as clothing, armour, hair or even beaks and claws can be added to create new layers of visual interest.

perspective

The term 'perspective' refers to the technique of representing three-dimensional objects on a two-dimensional surface, such as a piece of paper or a computer screen. The phenomenon that allows this approximation to work is that parallel lines appear to converge to one or more points on the horizon as they recede in the distance. This section looks at different perspective situations and how they are achieved.

THE VANISHING POINT

Building on the 'train tracks' convergence phenomenon, an artist can accurately depict a number of different perspective conditions. The point on the horizon at which **parallel lines** appear to converge is called the **vanishing point**. Depending on the relationship of the viewer to the object, there may be **one, two or three** vanishing points.

ONE-POINT PERSPECTIVE

Generally speaking, in a one-point perspective view, the object being drawn in perspective is located **directly in front** of the viewer. The direction of the viewer's line of sight is **parallel** to the edges of the object.

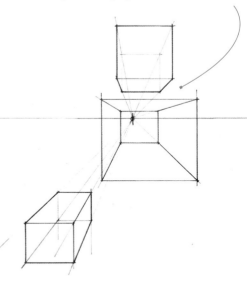

In these box shapes, the parallel edges appear to converge on the vanishing point on the horizon; all the other edges are parallel or perpendicular to each other.

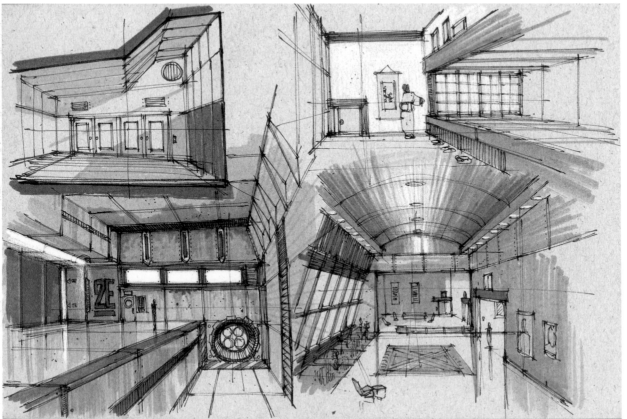

INTERIOR VIEWS

The views in these sketches are examples of one-point perspective, which is useful for depicting interior spaces. In these scenes, the viewer is standing in the room, facing directly ahead towards the horizon with the line of sight parallel to the edges of the room.

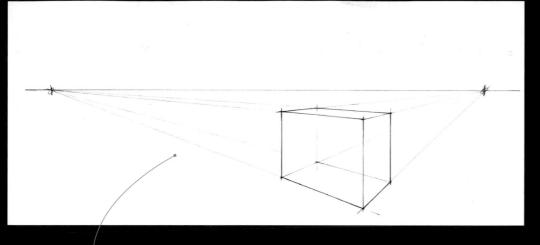

TWO-POINT PERSPECTIVE

When the observer's direction of view shifts relative to the edges of the object, so that the line of sight is **no longer parallel** to the edges, the object's lines converge on **two vanishing points** on the horizon. This type of perspective drawing can be effective for depicting an exterior environment close to eye level, such as the buildings on a street corner, or a stack of shipping containers at a dock.

Using two vanishing points gives a more realistic approximation of what you see when an object is at an angle to your line of sight. The vertical edges remain straight up and down.

SHANTY TOWN

This sketch of a floating shanty town is an example of two-point perspective. The red lines show that the vertical lines in the scene are (for the most part) vertical with respect to the view of the observer. The horizontal edges in the scene converge on two vanishing points, to the left and right, on the horizon. In this scene, the viewer's line of sight is directed at the horizon, but is at an angle with respect to the ground plan of the town.

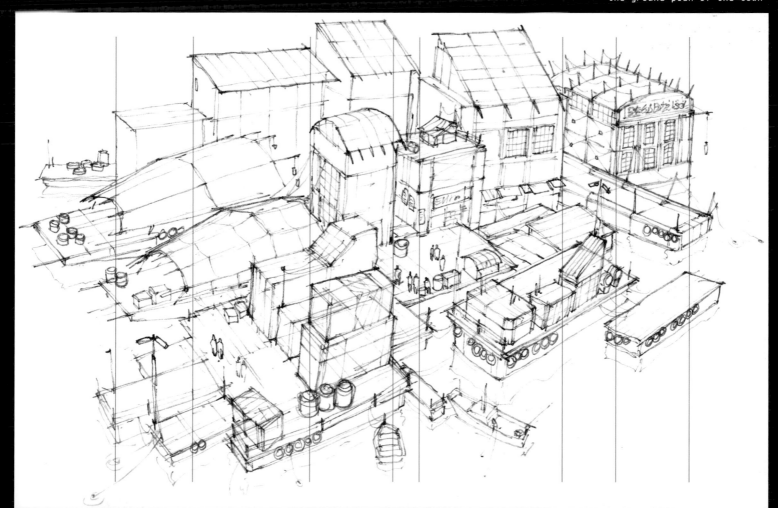

THREE-POINT PERSPECTIVE

When the viewer shifts his gaze **above or below the horizon**, so that his line of sight is **no longer parallel** to the plane of the ground, a **third vanishing point** is introduced. The vertical edges of the object then appear to converge at a point either far above or below the horizon line. This is the most dynamic of the different types of perspective drawings.

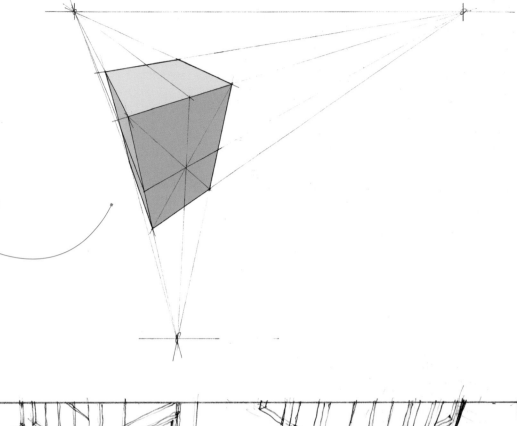

The viewer's line of sight is directed away from the horizon line to a point either above or below it. This imparts a sense of motion and dynamism.

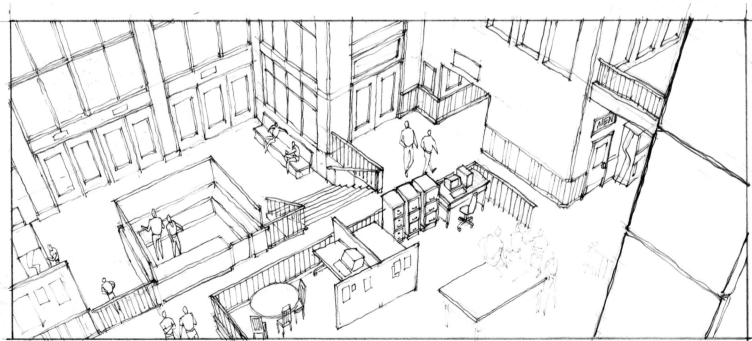

FLOOR PLAN

In this scene, the viewer is looking towards a point somewhere below the horizon and also at an angle relative to the floor plan of the building. The vertical lines in the scene converge at a point far below the horizon, and the horizontal lines converge to vanishing points to the left and right of the viewer.

PERSPECTIVE EFFECTS ON FIGURES

The basic geometric shapes of a figure also conform to the rules of perspective. Unlike drawing a static scene, however, the various components of a figure might be seen at **different angles** to the viewer's line of sight – the arms might be viewed at a different angle to the torso, for example. This means that different body parts might each have **their own vanishing point**, which complicates matters considerably.

Trying to establish vanishing points and horizon lines for each part of a body can get out of hand quickly, especially if there is more than one figure in a drawing. Also, paying too much attention to the perspective of individual parts can affect the **rhythm and spontaneity** of a figure drawing. However, with practice, achieving the correct perspective will come naturally.

FLYBORG

This insect-like cyborg shown here can be thought of as being in a three-point perspective situation; the box of the torso is turned on an angle relative to the viewer, and also appears to be located below the horizon line. The individual parts of the body (arms, legs, etc.) occupy their own perspective views, with different vanishing points depending on their orientation with respect to the viewer.

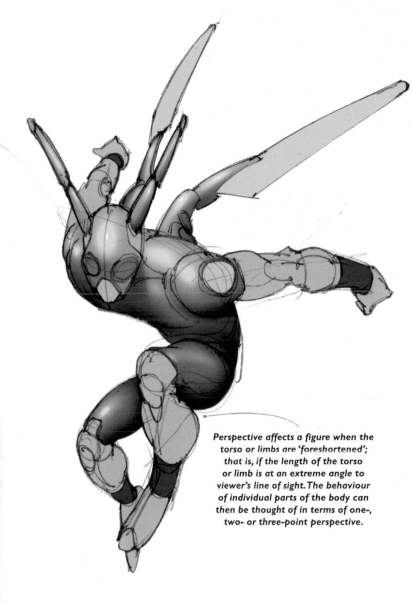

Perspective affects a figure when the torso or limbs are 'foreshortened'; that is, if the length of the torso or limb is at an extreme angle to viewer's line of sight. The behaviour of individual parts of the body can then be thought of in terms of one-, two- or three-point perspective.

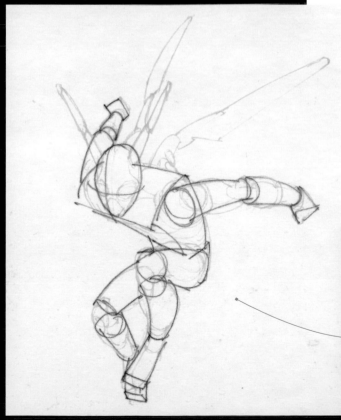

The various components are three-dimensional objects with edges that recede and converge, just like the cubes in the earlier examples.

colour

Colour is a physical property exhibited by all objects in the presence of light. When light strikes the surface of an object, a portion of the light is reflected back, which is what we perceive as its colour. Because much of our understanding of the world comes to us in visual form, colour is a very important topic for an illustrator, as it is one of the principal ways of communicating with the viewer. This section explores the basics of colour theory, which is then put into practice on the following pages.

COLOUR THEORY

As an artist you are likely to be aware of the colour wheel and the basic concepts of colour mixing. Red, yellow and blue are considered **'primary'** colours, meaning all the other colours in the spectrum can be obtained by mixing varying amounts of red, yellow and blue together, forming **'secondary'** and **'tertiary'** colours. The term **'complementary'** refers to colours on opposite sides of the colour wheel – for example, red and green, blue and orange, or yellow and purple. Colour can be thought of in more detail as consisting of four components: **hue**, **intensity** (or **saturation**), **temperature** and **value**. Being aware of these components of colour allows an artist to have a better understanding and greater control of colour in creating an illustration.

One aspect of colour choice in particular is **how colours work together**. Complementary colours placed next to or near each other will appear to **vibrate**. The reason for this is related to the physiology of the eye; when you look at a certain colour (let's say orange) for a few minutes, and then look at a blank white surface, the complementary colour (blue) appears as an after-image. Placing complementary colours near each other in an illustration makes each colour seem brighter and more vibrant, a phenomenon that can be very useful to the artist.

HUE

Hue refers to the **principal characteristic** of what we consider colour; the property we would describe using terms such as red, orange, green or magenta. The terms 'primary', 'secondary', 'tertiary' and 'complementary' describe hue.

INTENSITY/SATURATION

Intensity or saturation describes how **strongly** or **intensely** a colour appears. A colour, red for example, mixed with some amount of white or grey will appear less intense or saturated than a sample of pure red colour.

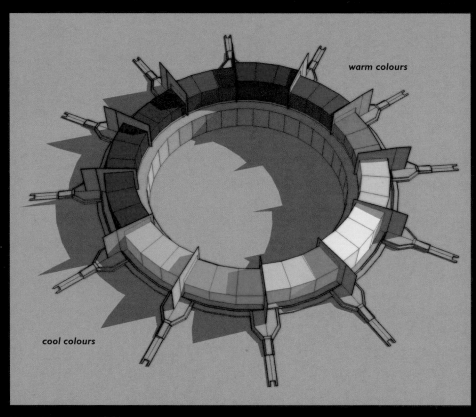

warm colours

cool colours

THE COLOUR WHEEL

This three-dimensional model of the colour wheel shows how the primary colours (red, yellow and blue) relate to each other, and how they can combine to form the other colours in the spectrum.

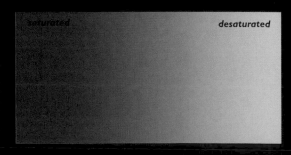

saturated desaturated

SATURATION POINT

As a colour becomes less saturated, the base colour (red in this case) is increasingly influenced by its complementary colour, causing it to approach a grey tone.

TEMPERATURE

Temperature is a relative term describing the **warmth** or **coolness** of a colour. Looking at the colour wheel gives the first clue to interpreting colour temperature. On one side of the wheel, the range of colour that includes the greens, blues and violets is considered 'cool'. The other side of the wheel contains the reds, yellows and oranges and is considered 'warm'. However, colour temperature is not a simple as that. What complicates matters somewhat is that individual colours can also exhibit warmth or coolness. This kind of colour temperature is much more **relative**, and is dependent on the colours adjacent to it in an image, as revealed in the example illustration, right.

VALUE

Value refers to the **lightness** or **darkness** of a colour, and is one of the most important tools for an artist in creating an effective, convincing illustration. In its simplest expression, value can be understood as the range of greys from white to black. In a black-and-white image, the range of greys between the extremes of white and black can provide information about **shape, light and shadow, and even distance**.

Colour can also exhibit value, and an artist has a number of different ways to modulate the value of a colour. The simplest way to affect a colour's value is to add either white or black. This method has some disadvantages: adding white tends to wash out a colour, reducing its intensity and saturation, and adding black also tends to deaden a colour, again reducing saturation.

Value can also be controlled using **combinations** of colour. For example, adding a small amount of yellow to green can lighten the green colour's value. The thing to watch out for, of course, is that using other colours to modulate value can also affect a colour's hue (see opposite).

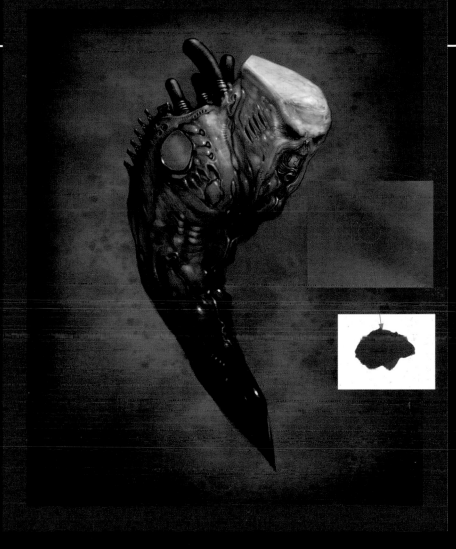

WAR FOETUS

In this image of a genetically engineered war-creature, the palette consists primarily of warm colours in the range of reds, oranges and browns. There are some spots that appear cool — for example the small patch of skin indicated with the red outline. If you examine that patch of colour outside the context of the surrounding colours, you realize that its colour is actually a very desaturated reddish brown. It only appears cool in temperature relative to the more saturated, warm colours around it.

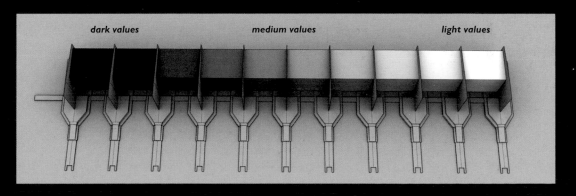

dark values medium values light values

VALUE RANGE

The object shown here illustrates the concept of value in grayscale. Artists use value to indicate the effect of light and shadow on an object. Value and colour are closely intertwined; both are necessary to convey reality in an illustration in a convincing way.

COLOUR PALETTES

Taking the basics of **colour theory** outlined on pages 26–27, which revealed the various ways an artist can **control colour** in an illustration, the following typical science-fiction images show how some of those concepts can be used to formulate different colour strategies in **practical situations**.

NOS-MECH

In some cases, two complementary colours can exert almost the same degree of influence in an illustration. The character shown here is lit in an almost theatrical manner, with cool blue light from one side and a warm pink-orange light from the other. The control of the value ranges conveys most of the information about form and detail; colour in this illustration is much more of a set of stylistic choices than a faithful depiction of reality.

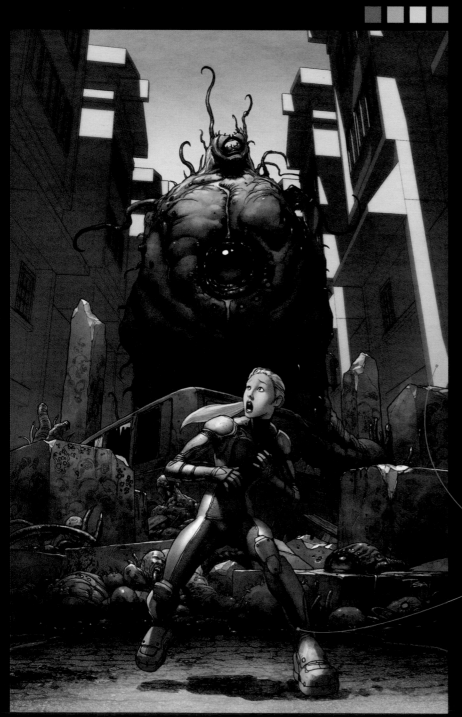

In this image, there is not a clear dominant colour or colour temperature.

The character is silhouetted against a neutral band of colour that is affected by both the cool blue and warm pink-orange light sources.

The light source in this scene is a warm colour, which affects the palette in a global way.

The main character is dressed in a cool blue outfit using slightly more intense shades of blue and purple to contrast with the environment.

ENCOUNTER

This image consists primarily of warm tones, mainly different shades of red, orange and brown. Cool temperature colours are used in the shadows, but in a way that is clearly subservient to the general warm colour scheme.

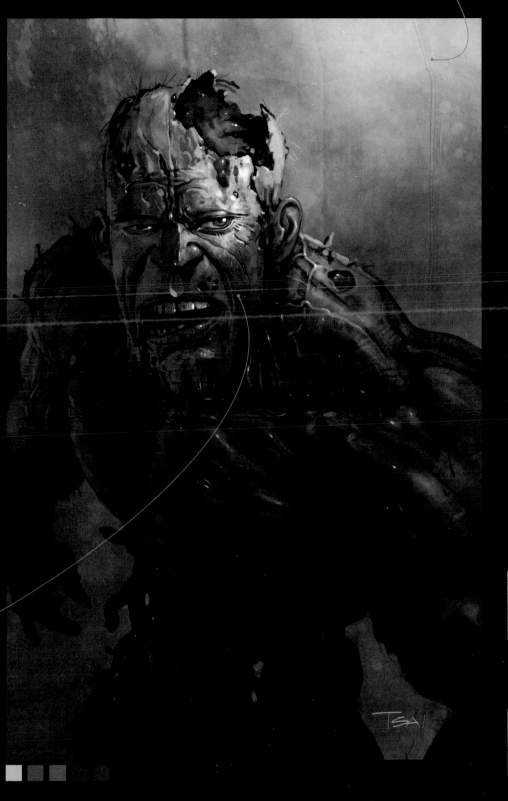

PROBE ROBOT

This illustration of an unmanned probe-robot
scouting some alien structures is an example
of a very straightforward colour temperature
scheme. The overall scene is rendered in
monochromatic blues and greys including light
and shadows. The single spot of warm colour
is localized in the probe robot itself.

*A colour treatment like this is very effective
at focusing the viewer's attention on a
specific object or area in an illustration.*

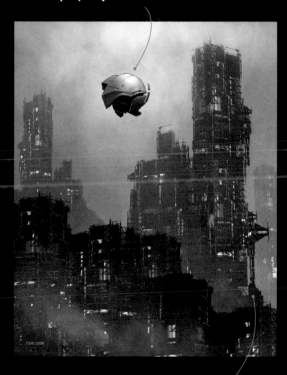

*This is much more of a graphic
treatment of colour temperature,
and not an attempt to show
real-world lighting and colour.*

*The values of the colours in this
scene are controlled to focus
attention on the zombie's face.*

ZOMBIE

This image uses a fairly narrow range of
hues, remaining for the most part within the
yellow-green-blue segments of the colour
wheel. Some spots of desaturated red provide
some complementary colour contrast and are
used to highlight brains and various blobs of
guts. Overall, there is a gradient of colour
from warm yellow to cool blue, which is also
reflected in the value gradient from light to
dark in the same direction.

The following pages demonstrate some of the processes needed to create a science-fiction illustration. Beginning with assembling a library of inspirational and reference images, to becoming comfortable with quick sketching as a way of cataloguing ideas, and finally to working up a completed full-colour image from basic lines and shapes, these examples and short demonstrations will lay out one of many possible paths to a finished illustration.

INSPIRATION AND REFERENCE

For an artist, maintaining a good **library** of reference and inspirational photos is a good practice. An illustrator working in science fiction needs to be able to create **compelling imagery** that feels **new and exciting** to the average viewer. This requires a **careful balance** between **the familiar** and **the unexpected**; too much of the familiar can result in an unremarkable image, and too much of the unexpected can create an image that the viewer is unable to relate to.

URBAN LOCATIONS

A lot of the more memorable science-fiction visuals, particularly from recent movies, borrow quite a bit from modern-day scenes that would seem familiar to an average person. For example, the film *Blade Runner* featured some scenes in early 21st century Los Angeles (a futuristic period at the time the film came out), which had much in common with street scenes from modern Hong Kong and Japan.

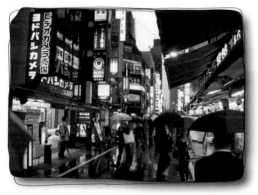

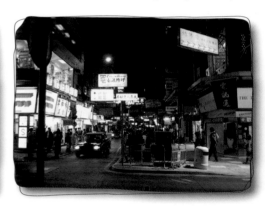

INDUSTRIAL DESIGN

Photos of heavy construction machinery and industrial structures can also provide great visual inspiration. Construction vehicles feature lots of telescoping, hinged components that can look equally at home on giant robots or spaceship interiors. Industrial architecture can form the basis for space stations or extraterrestrial outposts.

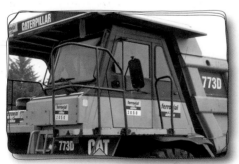
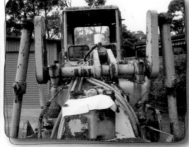
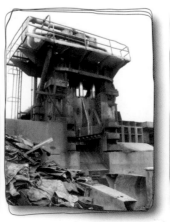
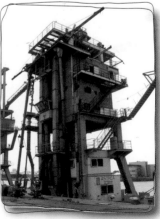

Images courtesy of www.cgtextures.com

SKETCHING

By keeping some form of sketchbook, whether that is a bound volume like the ones you can buy in any good art supplies shop, or just a stack of loose paper kept within easy reach, an artist has a means of recording interesting **ideas** or idea fragments, and also practising **brain–hand–eye coordination**. By their very nature, sketches require less of an investment of time and effort than finished drawings and paintings. Sketches allow you to focus only on those aspects of a drawing that interest you, whether that's exploring marker technique, developing the shape of an alien's head, or trying out different silhouettes for your space-opera villain. The sketches shown here provided a means for early **brainstorming** and **problem solving**.

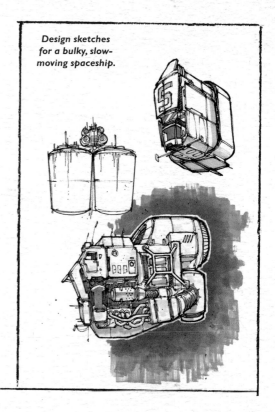

Design sketches for a bulky, slow-moving spaceship.

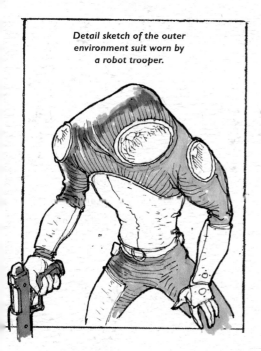

Detail sketch of the outer environment suit worn by a robot trooper.

Small one- and two-person vehicle designs for an illegal racing league.

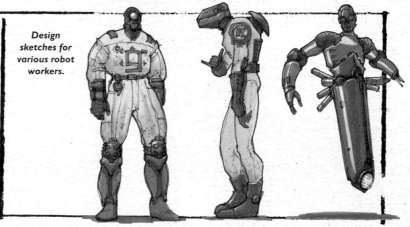

A short-range utility vehicle similar to a pick-up truck that a modern-day handyman might drive.

Robotic trooper design sketches.

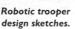

Design sketches for various robot workers.

DRAWING

This sequence takes you back to basics to reveal the method used to create a **detailed and polished line drawing of a simple object**. The process begins with blocking out the simple geometric forms (see pages 18–21), and moves through adding secondary forms and details in perspective, to tracing the line art on to the end media and finalizing the drawing.

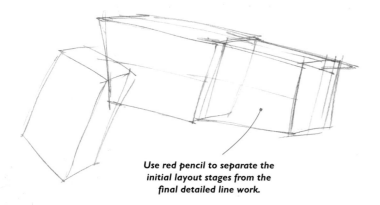

Use red pencil to separate the initial layout stages from the final detailed line work.

Phase 1: Basic geometry

The object you are going to draw is a laser pistol, such as one that might be used by characters in a science-fiction film. In its simplest form, it consists of three boxes. One box forms the handle of the gun and the other boxes form the barrel. Using a sheet of tracing or parchment paper and a red pencil, sketch out the three boxes as shown, introducing some angled edges and tapers in the gun barrel to add a dynamic feel to the gun design.

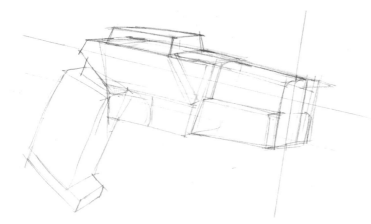

Phase 2: Secondary forms

Use a straightedge to draw in some perspective guidelines to keep the next layer of shapes correctly oriented. Start adding in some secondary forms, such as rails at the top of the barrel to mount a laser sight. Keep in mind the scale of the object – any part that would be operated with fingers should be scaled appropriately to the human hand in order to look convincing.

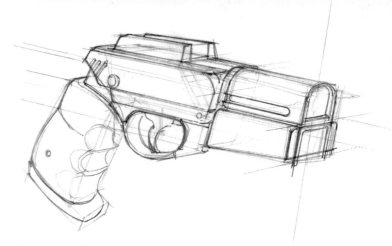

Phase 3: Refinement

Swap the red pencil for a normal lead pencil and begin refining the details laid down in the previous step. Introduce some rounded corners on the larger forms, expressing the nature of the gun's construction. This gun is made from overlapping and bent metal plates and solid blocks of metal with material routed out from two directions. Science fiction allows some leeway in terms of function or realism, but maintaining some visual cues from familiar reality helps to 'sell' the design. The lines can be kept fairly loose and sketchy at this stage, as you are still trying out ideas and determining the design.

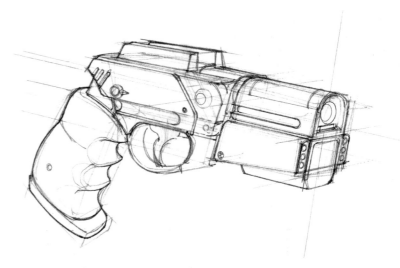

Phase 4: Detailing

Continue working across the different areas of the gun, adding the smallest level of detail – screws, fasteners, switches, etc. Use the construction guidelines to ensure the details conform to the correct perspective. Some of these new shapes can be added using straightedges and templates for greater accuracy. Begin the process of tightening up the line work, picking out the lines that feel most accurate and going over them more firmly in pencil. There is no secret to this – the more you train your eye and educate yourself in how objects behave in perspective, the better you will be at choosing the right lines.

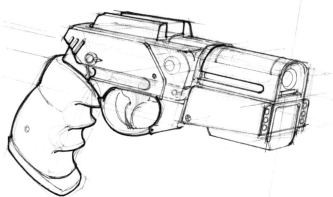

Phase 5: Line art creation

Lay a new piece of tracing or parchment paper on top of the sketch and begin the final line art using a pigment liner pen. Concentrate on the major shapes first, just like in the sketching process. The lines describing the main forms are important for establishing the silhouette of the gun, which can be thought of as the backbone of the drawing. If the silhouette is wrong, details won't save the image. Using tracing or parchment paper in this way means that your final line drawing will be clean, so you don't need to try to erase the perspective guidelines or sketchy marks made earlier.

Phase 6: Final image

Once the major forms are drawn, add the details and secondary shapes using smaller-diameter pens. Varying the line weight helps to communicate the form of the object by showing the relative importance of the different shapes. Varied line weights are also more pleasing to the eye than a drawing consisting entirely of a single line weight. Having an aesthetically pleasing balance of line weights with a smattering of marks indicating nicks and scratches creates a clean, precise drawing. Using straightedges and templates sparingly allows you to maintain a sense of precision while allowing the 'hand' of the artist to be visible in the final image.

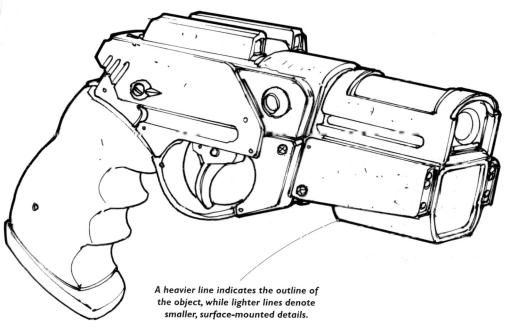

A heavier line indicates the outline of the object, while lighter lines denote smaller, surface-mounted details.

TIP: INKING THE DRAWING

The final drawing is rendered in ink, a darker and more permanent medium than pencil. Because it is difficult to adjust and revise an ink drawing, the underlying pencil drawing should be as close to perfect as possible – try not to leave any decisions for the inking stage. In the event that you do make a mistake when inking, it's not the end of the world. Inking errors can be covered up using opaque white paint or correction tape. Obviously this kind of correction should be avoided if at all possible, as drawing over white paint or correction tape affects the quality of the line.

TRADITIONAL PAINTING

Although most of the work in this book was created using digital painting tools, **the principles of drawing, colour and composition** remain the same no matter what media you use. This short demonstration shows how you would go about creating a colour painting of a robot using pencil, pigment liner pen, felt-tip pen and acrylic paints. The main paint colours used are yellow ochre, burnt umber, ultramarine blue and titanium white, applied to a sheet of watercolour block paper.

Phase 1: Line drawing

This robot (and the accompanying scale reference figure) are drawn using the principles of gesture, basic shape construction and refinement described on pages 18–21, with some perspective guidelines laid down with a straightedge. Draw just enough detail to provide a guide for later, as the opacity of the acrylic paint will allow you to refine or change details later as necessary.

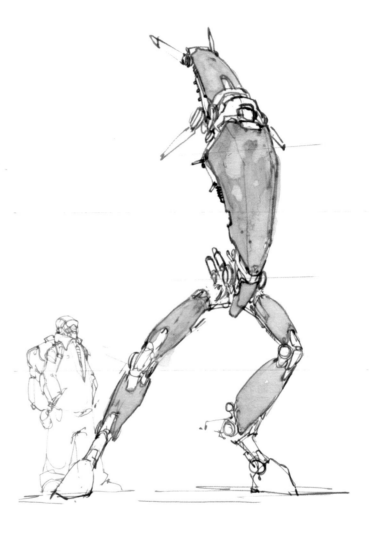

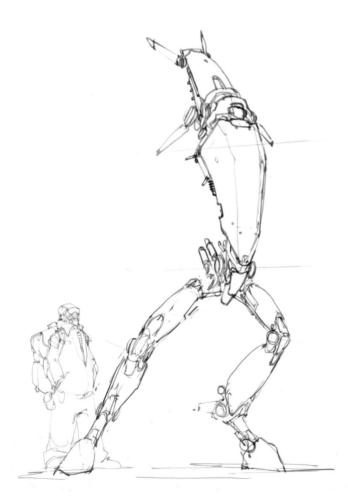

Phase 2: Main colour block-in

Mix a small amount of the yellow ochre paint with enough water to create a fairly dilute mixture. At this stage, you just want enough pigment to allow the line work to show through the paint. Use a large-diameter round brush to lay down the initial wash. Don't worry about creating a smooth, even texture, or even completely filling the shapes; some variation in paint thickness and some areas of paper showing through will add interest and variety to the image, which is one of the main advantages of traditional media. It's nice to see the hand of the artist in the media, which is more difficult to accomplish with digital painting tools.

Phase 3: Secondary areas of colour

Mix up a small amount of burnt umber, again dilute enough that the line work can show through fairly well. Wash in a light tone over the figure in the background, keeping the colour pale to suggest his distance from the robot, and also so that he does not compete too much with the main character. Using a smaller-diameter round brush, begin indicating lit and shadow sides of some of the small shapes on the robot, such as the foot and knee joints, dictated by a primary light source directly overhead.

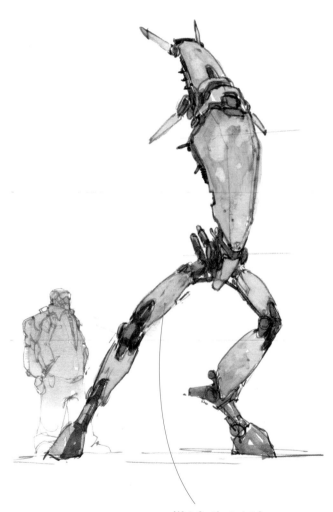

Wait for the paint from the previous step to dry completely to prevent the colours from running and mixing with each other.

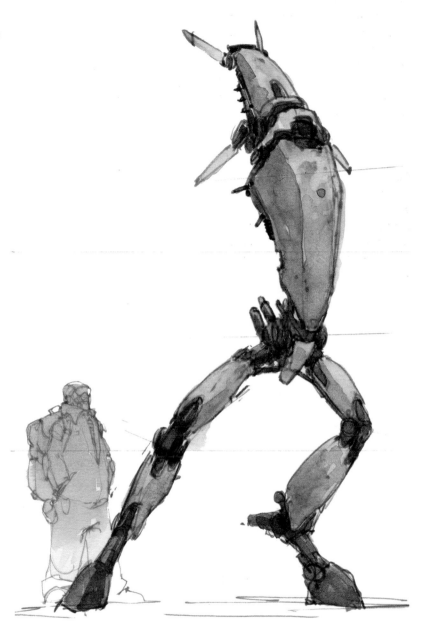

Phase 4: Volume creation

Using a dilute mixture of ultramarine blue, add some washes using a large-diameter round brush to the downward- and left-facing surfaces of the yellow panels of the robot's body. The blue is used to indicate shadow but the cool temperature of the colour against the warmth of the yellow also adds some appealing colour vibration. As with the application of the yellow ochre, don't worry about creating perfectly smooth washes. Drips, missed spots and other variations create visual interest and help imply a sense of the weathered metal surfaces.

Phase 5: Detail establishment

Mix up some ultramarine blue and burnt umber, a little thicker than you have been using previously. The goal is to create an opaque, dark colour to use for the metal joint details. Adding the blue cools the temperature of the colour slightly, which is more appropriate for rendering the metal parts. Follow the lighting scheme set up initially and apply the paint with the small-diameter round brush to areas of the metal joints and various 'greebles' (see page 80) that are in shade or cast shadow. Because the paint is more opaque, you can also use it to clean up some of the edges between the mechanical parts and the yellow exterior. Use a large-diameter round brush to wash in a patch of blue on the ground, indicating a cast shadow.

Phase 6: Detail refinement

After allowing the previous layer of paint to dry, step back and evaluate the painting, checking to see if any areas need additional refinement or emphasis. For example, some of the edges of the exterior plating near the top of the robot's head can be made a little crisper. Use titanium white to begin adding the highlights, such as along the outside corner of the topmost volume of the head. Use a very small-diameter round brush for the highlights and for cleaning up edges. Use the same brush to add suggestions of shadow on the background figure using some of the cool blue pigment used for the cast shadow on the ground.

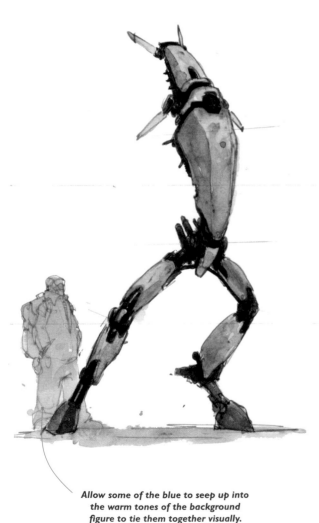

Allow some of the blue to seep up into the warm tones of the background figure to tie them together visually.

Phase 7: Further line work

Using a pigment liner pen, start adding in some of the line work that was covered up during the painting process. Not every single line needs to be called out on the drawing; some edges can be implied rather than specifically delineated. In particular, use the pen to outline the main forms, to crisp up the edges. Take the opportunity at this stage to add some new details to the robot, such as panel lines, screws, vent holes and details of that nature.

Phase 8: Final image

Use some titanium white, with a small-diameter brush again, to finish up some of the details, adding highlights to the mechanical parts and edges where panel surfaces create corners that catch the light. Use a red felt-tip pen to add a graphic to the front of the robot's body, adding a whimsical aspect as well as a face to help the viewer relate to the robot. Finally, remove the perspective guidelines with a kneaded eraser to present a slightly cleaner painting. Using traditional paint and paper or canvas to create an illustration has some drawbacks compared to digital painting, but what it offers is a richness and liveliness that is more difficult to achieve with digital tools. Applying colour in a loose, organic and sketchy way as shown here results in a very tactile, lively final piece.

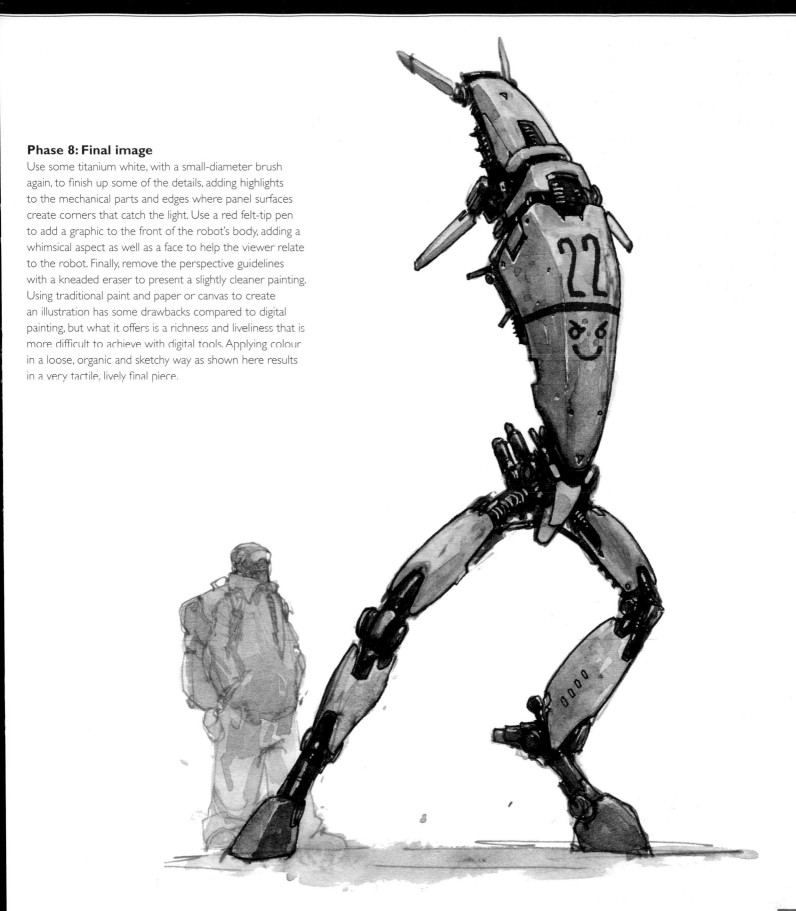

DIGITAL PAINTING

The digital art revolution has introduced huge changes in the way the majority of artists work. While it is still possible to create fantastic illustrations using traditional media alone (as the demonstration on pages 34–37 shows), the development of computerized painting software has transformed the process, allowing far greater possibilities for **image manipulation** and **special effects**. The main advantages that digital tools offer in comparison to traditional methods are the ease of colour mixing and, of course, the ability to 'undo'. This demonstration looks at how **digital software** can be used to create an atmospheric image in a post-apocalyptic setting.

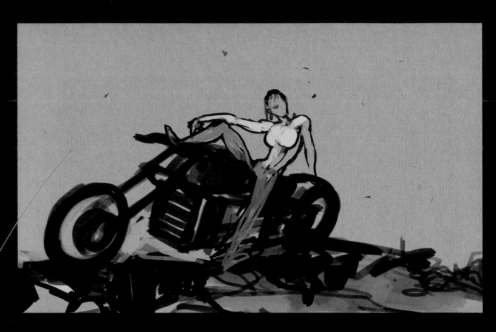

A medium-toned background allows values to be brighter or darker as needed, which is more flexible than beginning with a pure white background.

Phase 1: Rough sketch

Digital paintings often start out either as a line drawing, a rough colour block-in or, as here, a combination of the two. Begin with a neutral, medium-toned background, which can either be laid down by filling the canvas with the Paint Bucket tool, or, for added texture, by scanning in a piece of cardboard and dropping this in as the background layer. Use a dark, reddish brown to sketch in the main figure, her motorcycle and some suggestion of rubble-strewn ground, using square 'chalk' brushes of varying diameter. Programs such as Photoshop and Painter have default brushes that mimic natural media; Painter is more specific about this than Photoshop. You can also add some spots of colour (the swatches of green and brown seen at the bottom of the image and the blue of her jeans) to inform the colour palette of the final piece.

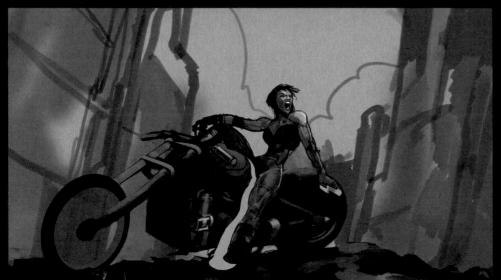

Phase 2: Paint and adjust

Start adding colour and detail to define the character and her vehicle, using a combination of round and square brushes, including a very small-diameter brush or pen for some of the finer details. Establish a main light direction from above and to the right. Take advantage of the Selection and Transform tools to cut, paste and alter sections of the painting. Use these tools to tip the motorcycle to a more upright position. Begin establishing a background of abandoned buildings, using a cool blue to contrast with the warm colours of the foreground, using large-diameter airbrushes and chalk brushes for harder edges. Blocking in a specific expression on the character's face at this point imbues the piece with a sense of personality that will help guide the rest of the painting. This can be done with a small-diameter round brush.

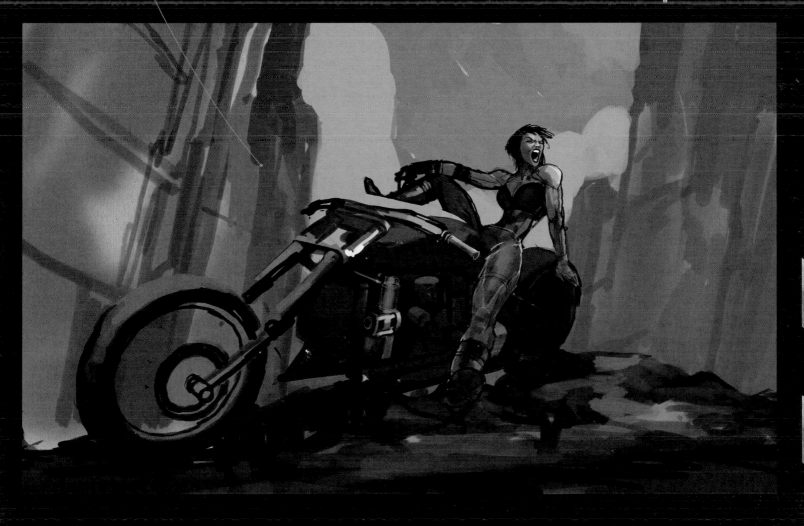

Phase 3: Further adjustments

Using the Selection tool and the Move tool, move the foreground rubble, the character, and all of the vehicle except the front wheel up and to the right. This gives the motorcycle a more exaggerated, chopper-like stance, and also centres the character in the composition, adding some breathing room to the foreground. As you have not started adding the details yet, you can be fairly loose when making the selection – use the Lasso Selection tool to create a very rough selection around the elements that you want to move.

Phase 4: Final bike adjustments

Use a combination of the Selection and Transform tools and simple brush painting to adjust the angle of the motorcycle, turning it slightly anticlockwise to give a more foreshortened view of it. The overall placement and proportions of the character and vehicle should feel more satisfying now than in the original sketch. Begin blocking in some of the sky in the background, and darken the blank areas of the ground plane in front of the character, using some of the colours and values placed there as reference in Phase 1. Use round brushes of varying diameter for the cloud formations in the sky and a combination of round and chalk brushes for the foreground.

Transforming the image to this more extreme angle creates a slight fish-eye lens effect and gives the piece a sense of motion.

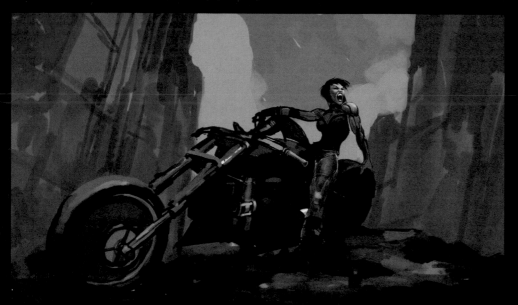

Phase 5: Solidification

Begin working on the background, bringing the tones towards a slightly darker value and working some colour into the ground plane using round and chalk brushes. Try to maintain the cool/warm colour temperature separation between background and foreground. The character's face should serve as the focus in this piece; increase the value contrast in that area by playing up the warm, bright pink and yellow tones, which contrast against the darkness of her hair. Introduce some spots of warm magenta and yellow-green on the ground near her foot, coming from the same light source, using round and chalk brushes. The left and right sides of the image can remain strongly influenced by the cool blues and greys, which helps focus attention on the character in the centre.

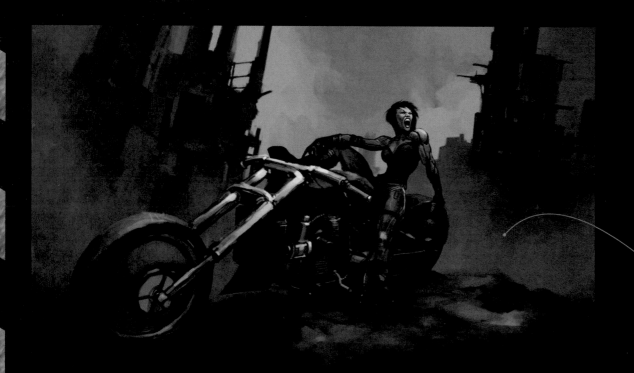

The fog has the effect of pushing the buildings further into the background, particularly where they meet the ground.

Phase 6: Creating focus

Add detail to the silhouettes of the buildings, but not so much that they detract from the main character. Use a combination of airbrushes and chalk brushes to paint in some atmospheric cool grey fog. Blend some of the colours of the ground into the wheels creating some lost edges. Look for opportunities to create more lost edges, such as on the far left, where the foreground gets lost in the fog. These engage the viewer, allowing the mind to actively fill in the details. The chrome of the motorcycle's handlebars and front forks exhibits high contrast and reflectance. Use the chalk brush to paint gradient stripes along their lengths, going from a light blue to darker grey. Follow this with narrower strokes of darker warm grey to indicate the environment being reflected.

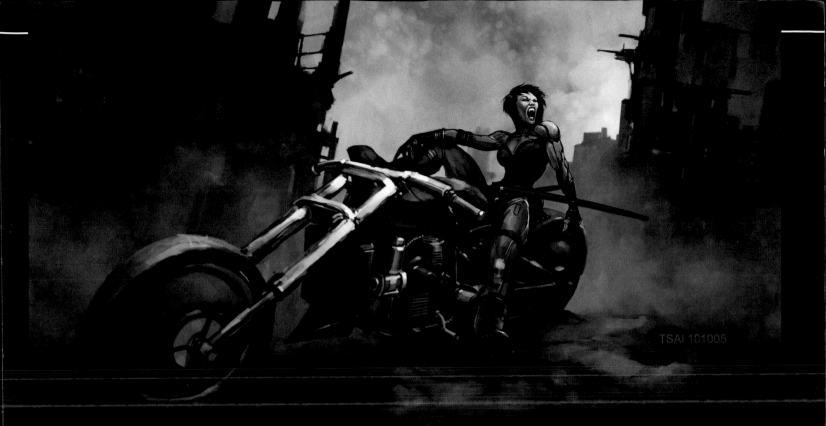

TSAI 101005

Phase 7: Final image

Finish the detail stage, moving around the image to avoid spending too much time on any one spot. Use a scan of paint droplets on a piece of watercolour paper to add some noise and texture. Add the scan to the image on an Overlay layer (see Tip), and use the Levels adjustment to increase the value range. This will brighten up some of the lighter areas of the sky, and make the darker areas feel richer and deeper. Introducing an 'analogue' element in this way helps mitigate the digital feel, although it's obviously not the same as creating a piece entirely with traditional media. What programs like Photoshop and Painter offer, as we have seen, is the ability to adjust and edit the image on the fly. This gives you tremendous flexibility and speed in working towards a successful final image.

TIP: LAYER BLENDING MODES

One very useful tool unique to digital painting programs such as Photoshop and Painter is a feature called Layer Blending Modes. By changing the mode of a layer you can control the way the contents of that layer affect the layer underneath. For example, adding images of ink blots, paint splatters and paper grain on a new layer on top of your image using 'Overlay' mode adds texture and variety, particularly in areas of broad, flat colour. Doing this can give the illustration an 'analogue' feel, mimicking the effect of traditional materials. Experiment with the different Blending Modes to discover the diverse range of effects that are possible.

DEMOS

BRINGING YOUR SCI-FI VISIONS TO LIFE

To create a finished illustration, an artist needs to bring together a number of different skills, as well as a solid idea or concept of what the image will be about. The first section of the book looked at various areas of knowledge that an artist must become familiar with in order to create a successful illustration. These included topics such as the simplification of objects into basic shapes, colour theory and perspective, and as well as a brief examination of some of the various digital and traditional media a modern illustrator might use. The following step-by-step demonstrations show how some of these different concepts and techniques can be combined, working together to help you execute your vision.

In each of the three chapters that follow you will find three stimulating demonstrations, guiding you through the creation of the image from laying down the very first marks to adding the final details. The instruction is applicable to both traditional and digital artists, with lots of helpful hints and technical tips along the way to help you finish your artwork to the highest possible standard.

aliens, robots, heroes and villains

From its earliest days in 1930s pulp magazines, science fiction has always been known for aliens, bug-eyed monsters, robots and other fantastical characters, in addition to human beings. The original *Star Trek* television show continued to popularize the concept of distinct races of aliens, with specific physical and behavioural traits, interacting with humanity. The cantina scene in the first *Star Wars* film 'A New Hope' is memorable for its fantastic depiction of a melting pot of alien races all gathered together in one spot.

In reality, if alien life exists it probably would appear almost unrecognizable to us. For entertainment purposes, we relate more to alien and robot characters if there is some element of familiarity. The tendency in science fiction is to alter the basic human body structure in some way, ranging from subtle (like some of the alien races in *Star Trek*) to extreme (as in **HR Giger's** Alien design from the film of the same name).

The demonstrations that follow take the approach of creating characters that the viewer can relate to by building on or altering the human body, or combining human characteristics with elements from other sources.

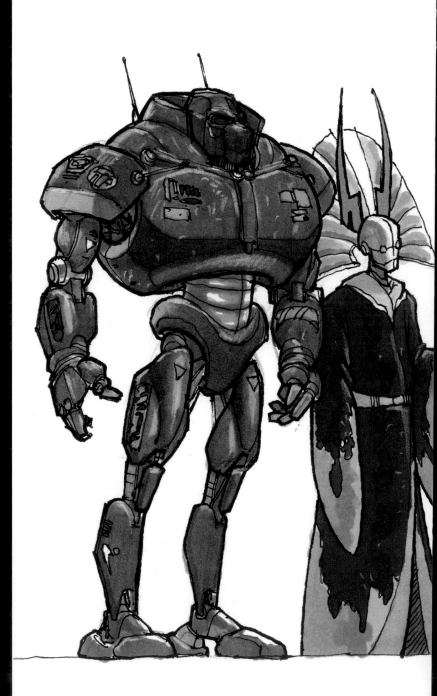

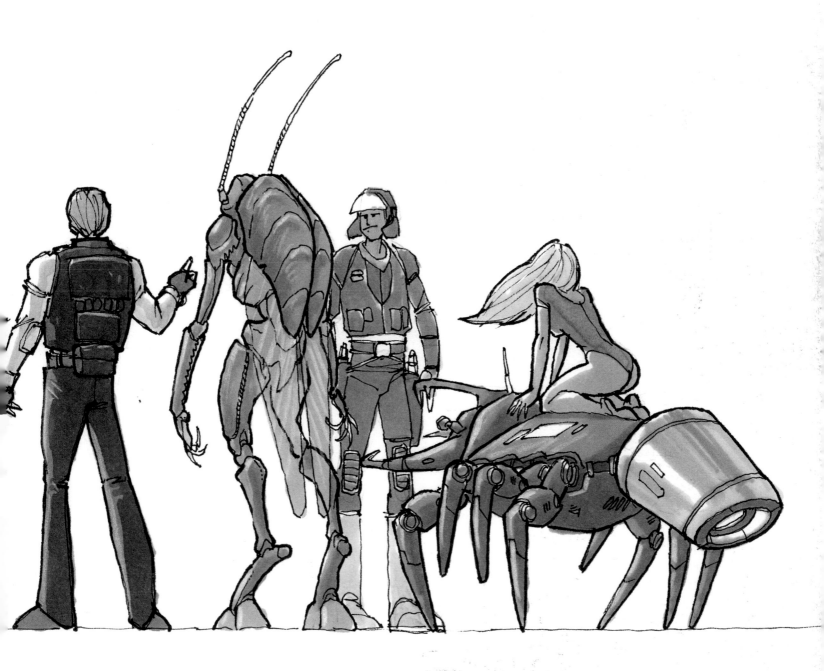

● humanoid ●

Human characters usually fulfil the role of protagonist in science-fiction stories, even though there are more options for character types in science fiction than there are in any other genre. One of the reasons for this is that readers and viewers identify more closely with humans, or at least human-like characters, which instantly makes a story more compelling. The character in this demonstration is Cygnus Lake from the space-opera story in the final section of the book (see pages 104–127). Due to an injury suffered on a past mission, her arms and parts of her skeleton have been replaced with high-tech mechanical prosthetic devices. As a cyborg, or 'cybernetic organism', she bridges the gap between human and robot characters. This exercise shows you how to construct a figure from an initial gesture line and build it up with basic geometry to a finished line drawing, which is then rendered in paint.

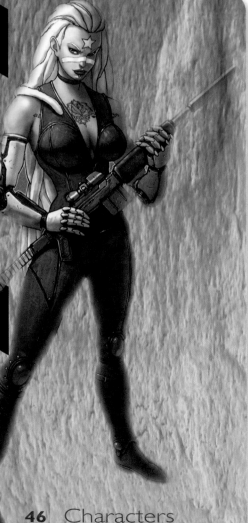

Phase 1: Gesture line

Human beings, like almost all living creatures, constantly change shape as they move through their environment. They differ from inanimate objects in that their silhouette shifts from moment to moment. With inanimate objects such as guns or spaceships, usually the first step is to block out the form using geometric shapes. For living creatures (or at least creatures that move, including robots) the best first step is one or two big strokes that represent the gesture of the character. Gesture can encompass many different things, but basically it is a combination of posture and attitude. The aim here is to draw Cygnus Lake in an alert state, carrying a laser rifle. The gesture line represents her standing pose – casual but watchful. The lines denoting her hips and shoulders indicate her laid-back but ready stance, also reflected by the tilt of her head.

Emotional states such as fear, anger, pride or alertness can all come through in a well-drawn gesture.

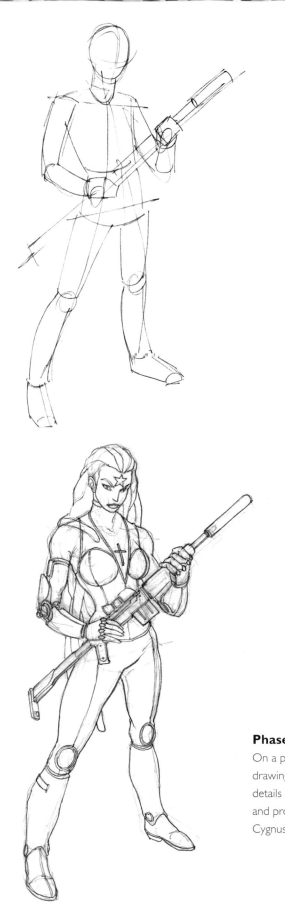

Phase 2: Basic geometry

Once you are happy with the pose and attitude of the gesture sketch, begin building the basic geometry (see pages 18–21). The human body can be represented mostly with cylinders, with an elongated box for the torso and a rough egg shape for the head. Tapering the cylinders of the limbs adds an element of grace to the figure, as does adding a slight curvature along the length of the cylinders. Hands and feet can be represented simply with boxes at this stage.

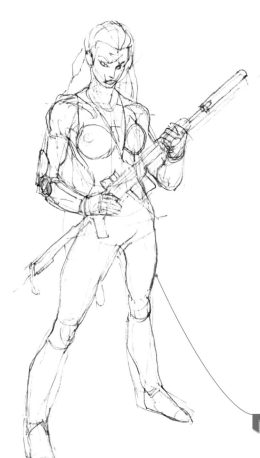

Phase 3: Anatomy build-up

Using the basic geometric forms as a guide, refine the shapes of the limbs, head and torso. Cygnus Lake is a cyborg with robotic arms, but her overall silhouette should read as a normal human being. Mark out important anatomical landmarks at this stage, such as facial features, joints, breasts and hair. The facial features are human, as is the placement of the joints in the arms and legs. The mechanical nature of the arms will be expressed through their details and material treatment. The goal with placing the landmarks is to create an accurate basis for the details to be added later.

Keep the line work loose and sketchy at this stage, giving yourself space to explore shapes and details.

Phase 4: Design solidification

On a piece of tracing or parchment paper laid over the initial sketch, finalize the line drawing, picking out the best lines laid down in the previous phase. Nail down the design details you were exploring in the sketch stage, such as the secondary shapes in the costume and prosthetic arms. The costume works best if it is cut to show off the transition between Cygnus Lake's human shoulders and mechanical arms, as well as the tattoo on her chest.

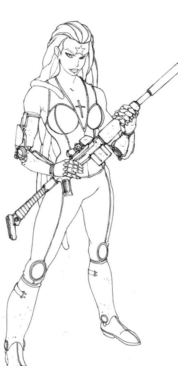

Phase 5: Line drawing refinement

Remove the sketch layer and examine the final line drawing for any quirks. Although she is standing at a three-quarter angle to the viewer, the effect of perspective is overly pronounced in her breasts, creating a little too much asymmetry. In reality, most people exhibit at least some degree of asymmetry in various parts of the body; in fact, this is what makes human beings look 'human'. In a drawing, asymmetry can sometimes work against you, as it can feel more like a drawing error than a deliberate action. One way to double-check this is to hold the drawing up to a mirror to observe it from a different point of view. This allows you to see the image in a new light, and reveals perspective or symmetry errors that might not have been obvious before.

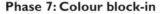

Phase 6: Line drawing finalized

Using a fine-tip pigment liner pen, go over the drawing, tightening up details and adding some indications of nicks and weathering on some of the non-skin surfaces. Pay particular attention to mechanically detailed areas such as the weapon and her cybernetic arms. The mechanical details and geometric shapes here should contrast with the organic, fluid lines in the rest of her body.

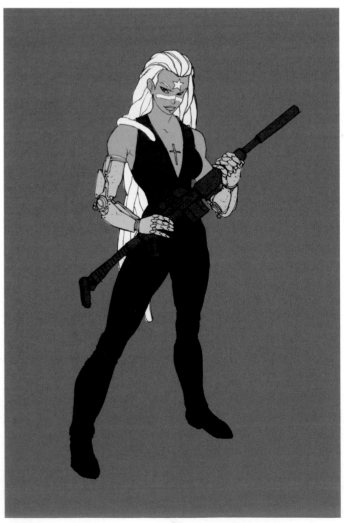

Phase 7: Colour block-in

If you are working digitally, scan the image and use the Levels tool to create a clean line drawing (see page 16). If you want to work traditionally, transfer your line drawing to the final media using a light box. Begin with a medium warm-toned background and then block in the main colours of the character. Using a dark colour for the costume creates nice contrast with the skin areas and the metal and synthetic surfaces of her artificial arms. Use a large, round brush and, if working digitally, take advantage of the Lasso and Paint Bucket tools to fill in large areas of flat colour quickly (see Tip, page 60). The warm, monochromatic colour palette will allow details of cool spot colours to create more contrast as the image develops.

Phase 8: Light direction and colour temperature

Establish the main light source above and to the left of the character and begin modelling the head and shoulders. Use a warm, pale yellow for the light and indicate shaded surfaces with a cooler blue-purple, using a soft-edged brush to create smooth transitions on the surface of the skin. Use a harder-edged brush to define the edges of the cast shadows, such as those that appear on her forehead just below her hairline. The colours are relative – compared to the warm yellow-tinted skin tones, the shadows appear bluish purple. The actual colour of these shaded areas should be closer to a less saturated red-orange, so that the colour in the scene does not become too garish.

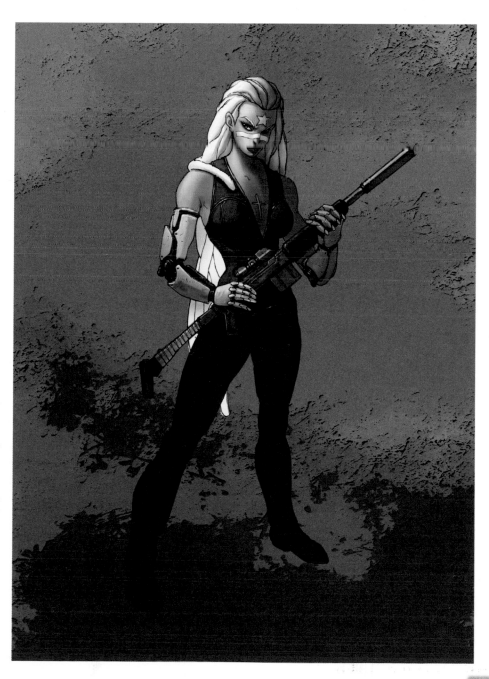

The natural colour of human lips is a shade of pink or brown. Use a blue-purple colour here instead to reinforce the idea that she is not entirely human.

Phase 9: Visual variety

Add some interest to the background by painting in some variations in colour and value with a large textured brush, but keep fairly close to the colour and value of the original background. If working digitally, another option is to drop a textured image on to a new layer in the background. Continue rendering the figure, keeping in mind the lighting scheme and colour temperatures. The prosthetic arms and the weapon in particular have some detailed mechanical areas (such as in the darker-coloured joints in her arms) that catch sharp highlights, differentiating them from the smoother gradients on her skin and portions of her costume. Add subtle white highlights on some of the more prominent dents and scratches on the artificial surfaces to help convey their material quality.

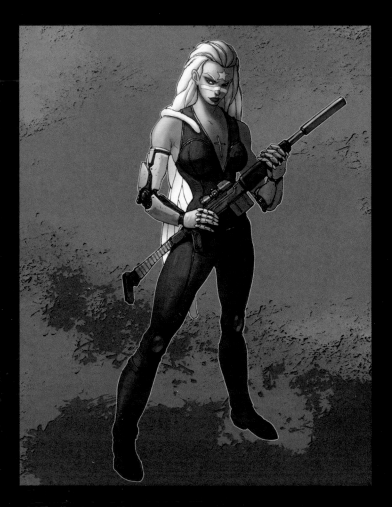

Phase 10: Focus and pop

Once the main rendering of the character is done, help create focus on the face and upper torso by adding a subtle semi-transparent blue-grey gradient on top of the figure, going from darker at the bottom to lighter near the head and shoulders. Adding a thin white outline around the figure is a simple graphic trick to 'pop' the figure off the background. This can be done using a small-diameter, hard-edged brush or pen, varying the line weight to add life and dynamism.

Phase 11: Final image

Correct any minor errors (including the asymmetry of the breasts mentioned in Phase 5) and make changes to details in the design, such as substituting the simple cross on her chest for a more ornate tattoo (to avoid the religious implication) and adjusting her facial features to reflect more realistic proportions. Add some spots of detail, such as metallic rivets and seams, to create interest in the costume; but make sure that these details don't distract from the face, chest and arms. Add some abstract Art Nouveau-inspired graphics to the background in pencil. These will help to convey the sense of a complex, multi-layered character that invites the viewer's interest and curiosity – how did she come to possess her cybernetic arms, and does she have other unseen artificial enhancements?

TIP: ESTABLISHING A SUBJECT—BACKGROUND RELATIONSHIP

One potential risk with illustrating a figure on a simple, non-specific background like this is that the figure can appear flat and two-dimensional. To combat this, make sure that you repeat some of the colours from the figure in the background. This will tie them together, creating a stronger relationship between the subject and the background, which will help to alleviate the 'pasted-on' feeling. The colours in this illustration were added with a large textured brush to give a random, splattered effect.

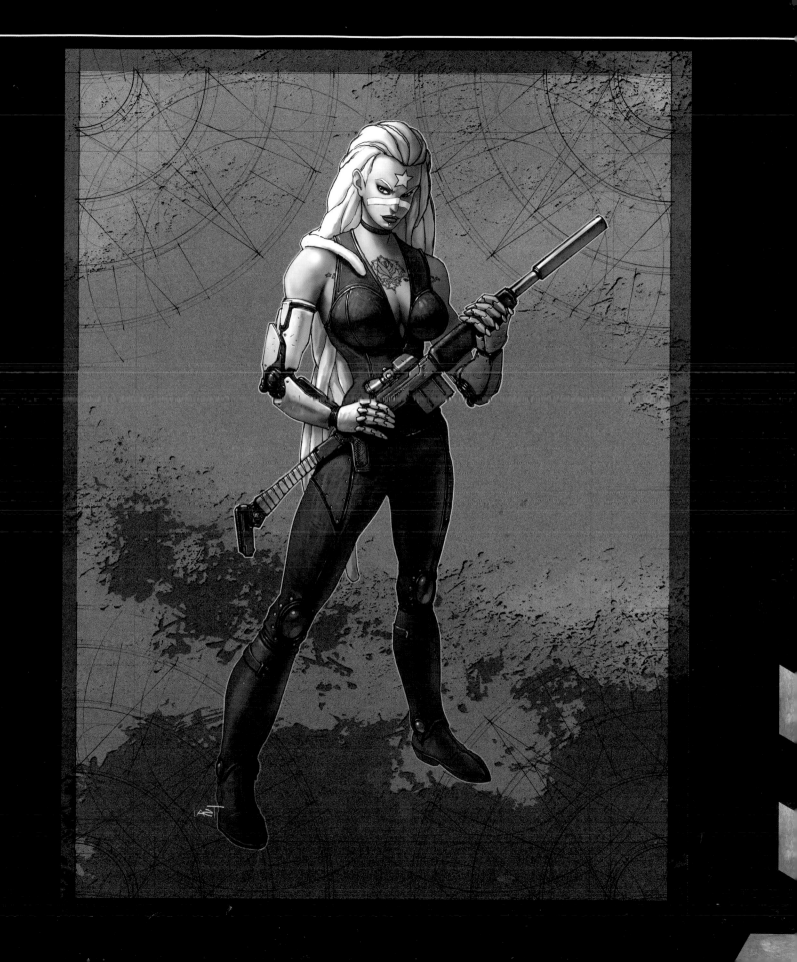

alien

Since the rise of the science-fiction pulp magazine in the 1930s, alien creatures have been depicted as 'little green men' or 'bug-eyed monsters' (BEM for short). From those early beginnings, visions of aliens have evolved and taken on many different forms. Steven Spielberg's *E.T.* was a friendlier, more relatable version. The 'grey alien' concept from TV shows such as *The X-Files* was a more emotionally distant type. Though 'greys' had a familiar bipedal form, their large, blank eyes created a disconcerting sense of anonymity. Ridley Scott's *Alien* upped the ante, going beyond being merely emotionally distant to scaring the pants off the viewer. Artist **HR Giger's** designs for the *Alien* film took the idea of alien biology in a new direction and set the tone for science-fiction movies to follow. The alien in this demonstration is a nod to the early pulp days but with a modern spin in the form of a more exaggerated, xenomorphic biology.

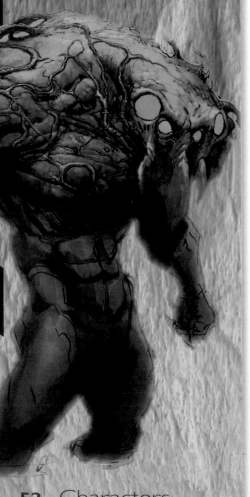

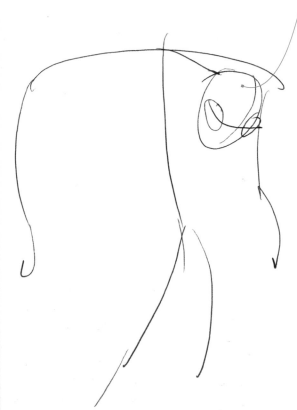

Establish the head somewhat below the shoulder line to add to the creature's primitive, bestial nature.

Phase 1: Proportions and gesture

To create a dynamic alien, go for more of a 'bug-eyed monster' than the stereotypical 'little green man'. Lay down some initial lines to establish the proportions and gesture of the creature, giving him the air of a hulking, semi-intelligent being. Draw in the gesture lines to imply a wide, squat body, almost square in shape. Make the arms hang down to almost below the knees, emphasizing the monstrous proportions.

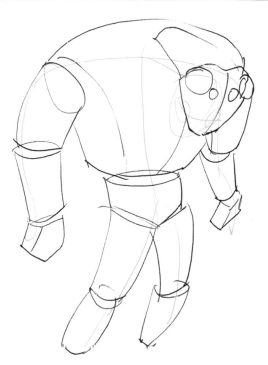

Phase 2: Basic geometry

Using the gesture sketch as a guide, begin laying in the geometric primitives making up the body of the alien (see pages 18–21). Most of the shapes used here are cylinders, with a slight taper and curve introduced into the shapes to mimic the rhythm of the initial gesture sketch. Exaggerate the size of the upper torso and arms to help imply his bulk. Do not draw the feet – in the final illustration, the aim is for the alien to be standing in some sort of fog or mist, to increase the eerie, pulp-magazine feel. Breaking the connection of the figure to the ground also conveys a subtle otherworldly aura.

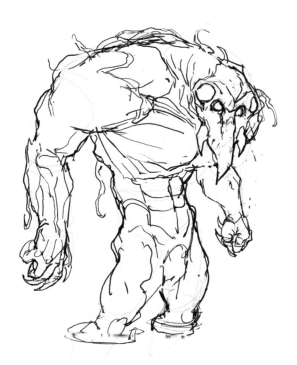

Phase 3: Anatomy refinement

On a piece of tracing or parchment paper laid over the initial drawing, sketch in a rough outline defining the body using an energetic, organic line to add hints of strange veins and growths interrupting the silhouette periodically. Using references, delineate some anatomical structures that roughly parallel those of a normal human body – joints and muscle groups such as abdominal and pectoral muscles. The head is where the alien's anatomy diverges from that of a human. Draw two pairs of 'bug' eyes of differing sizes, inspired by the eyes of a spider. In place of a nose and mouth, draw a strange, triple-beaked mouth structure.

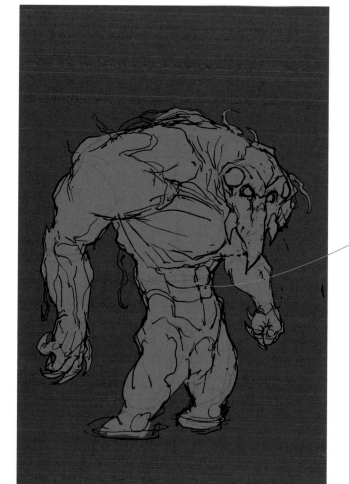

Keep both the alien and the background in a similar colour palette to help tie them together.

Phase 4: Colour block-in

If you are working digitally, scan the image and use the Levels tool to create a clean line drawing (see page 16). If working traditionally, transfer your line drawing to the final media using a light box. Establish the main colour palette for the piece. To recall the 'little green man' aspect of this character's history, use a medium-value cool green as the base colour of the creature, and fill the background with a darker blue-green. The end goal in terms of mood is to establish a sense of otherworldliness, showing the strange, alien creature appearing as if out of a mist.

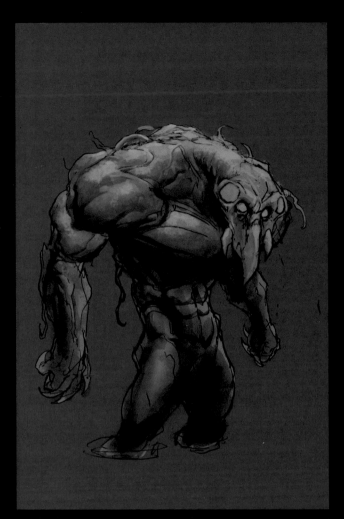

Phase 5: Light source and colour temperature

Establish the direction of the main light source directly overhead. Use a warm yellow, so that highlights and lit surfaces will have some warmth to contrast with the predominantly cool blues and greens. Start modelling the major muscle groups using a warmer green for the lit surfaces and cool blues and greys for the shadows. Give the upward-facing surfaces, such as the tops of the head and shoulders, the majority of colour and influence from the light source overhead. For this and the following phases, using an irregular, 'noisy' brush will yield the best results, creating a mottled, organic surface. Use a yellow-green for the eyes, which are the focal point.

Phase 6: Background variation

Using a large brush, begin altering the background by introducing variations in both value and colour. The goal is not to depict a specific location, but rather to maintain a particular mood being set up by the lighting and palette. Use variations in shape and value to suggest forms and light sources in the background, but keep things loose and don't get too specific. Push the overall colour palette of the background towards the blues to differentiate it from the character, but then add some of the alien's colours back into selected areas to maintain a colour relationship between the alien and its environment.

TIP: RENDERING THE VEINS AND GROWTHS

When adding interesting details to the skin surface, use a hard-edged, small-diameter brush. Pick up a dark blue colour from the background and paint the silhouettes of veins and looping growths on the alien's skin. Try to vary the shape and placement of the veins, aiming for a distribution that appears random. Render the veins by painting on the shapes

with a combination of greens and yellows. The veins have a different material quality than the rest of the skin, which you can indicate by creating smaller and more intense highlights. This suggests a more reflective surface, or the presence of moisture. Darken the downward-facing edges in the dark blue colour to imply a bit of cast shadow, creating a raised effect. For the vein-like structures, refer to roots and branches of trees, shrubs and vines, and note how they wrap around each other. There is a lot of great reference material for alien biology in plants, even in the vegetable section of your local supermarket!

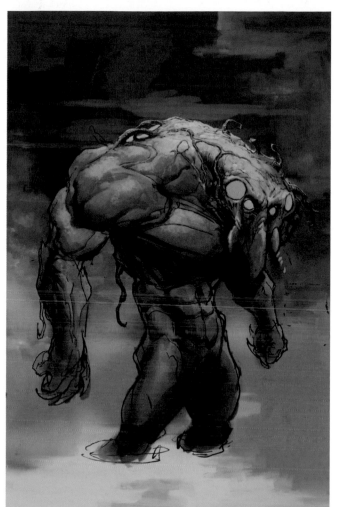

Phase 7: Lighting and colour refinement

Continue experimenting with the background colours. Create a rough gradient in the background from dark at the top to lighter at the bottom, to make the alien (which fades to darkness at the bottom) stand out more and to help draw the viewer's eye to the focal point of the face. Begin rendering details on the surface of the alien's body, using a bright yellow-green on the brightest areas and blue-greens in the shadows. The details to concentrate on here include irregular bumps and divots on the skin, and the gnarled veins that rise up off the skin and dangle like root tips (see Tip, opposite).

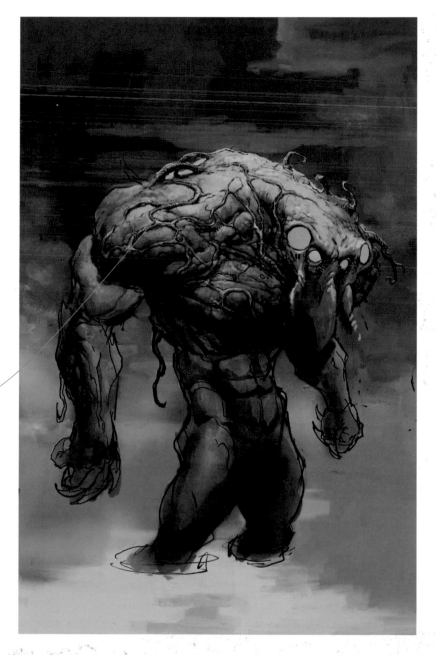

Add highlights using a small-diameter brush and a bright yellow-green colour.

Phase 8: Surface details

Carry on rendering the skin surface, paying attention to the volumes of individual muscle masses and other anatomical landmarks and how they should react to the lighting conditions. For example, the light from above will brighten the top part of the alien's chest, then fade to dark green as the volume rolls under, away from the light. The veins and growths on the surface of the skin are slightly brighter than the skin, and catch some point highlights. These highlights should be applied using the colour of the light source – bright yellows and yellow-greens. White should be used extremely sparingly as it will stand out too much.

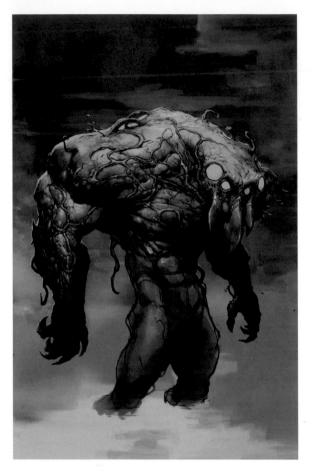

Phase 9: Rendering and tweaking

Continue the detail pass, working across each area of the body in turn. Try to remain aware of the image as a whole and not get too focused on one spot of detail. If necessary, major adjustments can be made, for example, increasing the width of his right arm, to exaggerate its misshapen quality. Pay attention to the face – the focal point of the illustration. Refine the graphic shape of the eyes and reserve one particular yellow colour them. Some hints of that yellow can appear in other areas to unify the image, but these should be subservient to the intensity of the colour in the eyes.

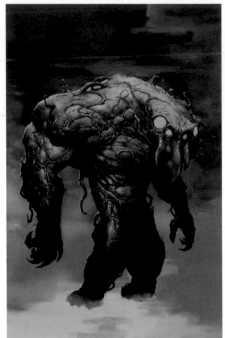

Phase 10: Rendering continues

Carry on rendering of the lower half of the body, fading the colour to a darker value to maintain the gradient from light to dark as the viewer's eye travels down the alien's body. Fade out the legs to indicate that it is standing in mist near the ground by bringing some of the blue colour from the background up on to the lower legs. Create a gradient between the mist colour and the dark green shadow of the alien's lower legs, blurring the boundary between them.

Suggest strange gases and particles in the air by painting in some light, splattery brushstrokes around the base of the alien.

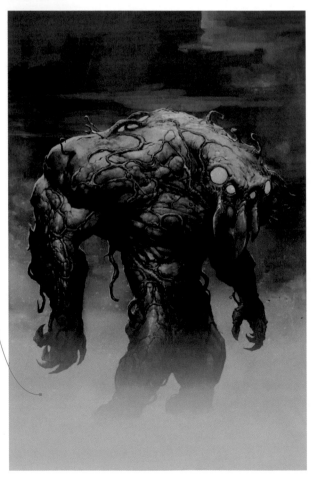

Phase 11: Atmosphere

Add more mist to the foreground, making the transition between the alien's legs and the fog even more gradual. Add a layer of fairly bright, warm yellowish-green on top, implying a thick, humid atmosphere between the alien and the viewer, starting out fully opaque and making it gradually more transparent as it climbs up the alien's body. Some of the detail will be lost, but the silhouette should still be readable.

Phase 12: Final image

Add a hint of complementary colour to the face with a very fine brush to help draw attention to the focal point. Subtle orange/brown shades create a feeling of material change between the beak structures and the rest of the face. Eyes are usually rendered as glossy, highly reflective surfaces and mammalian eyes tend to be moist. Rendering the eyes with more of a matt, non-reflective surface adds to the sense of strangeness. To mimic the effect of an old magazine cover, use an irregular brush with a white colour to add some distressing to the edges of the image. Layer a very translucent wash of sepia colour over the image, mellowing the effect somewhat and adding a unifying colour influence to the whole illustration. The final effect is one of a vintage pulp BEM, characterized by his massive bulk, spider-like eyes, and the eerie mist … run for your life!

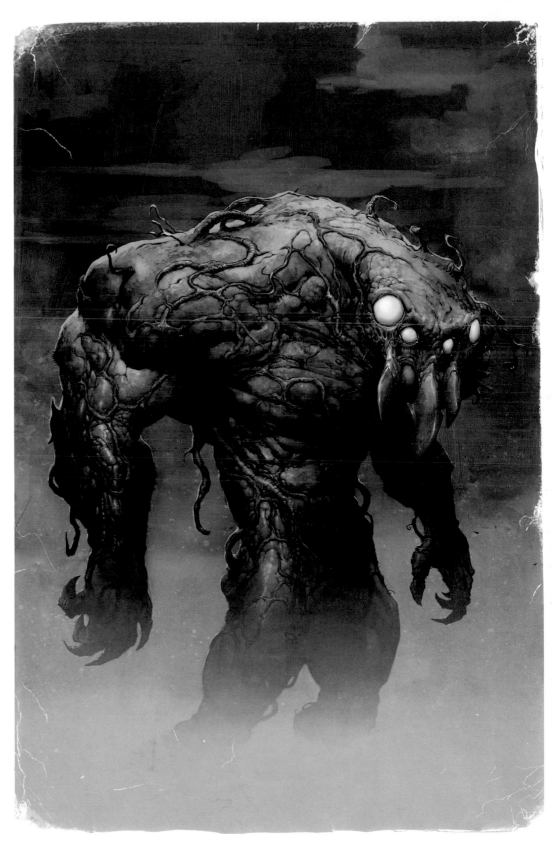

robot

Czech writer Karel Čapek created the first concept of a robot creature in his 1921 play *R.U.R.* (*Rossum's Universal Robots*). The word 'robot' derives from the Czech word *robota*, meaning 'work' or 'labour'. Since then, robots, or mechanoids as they are also known, have become one of the mainstays of the science-fiction genre and have evolved into many different forms. Fully robotic characters can take on many different shapes, from the two-legged boxes in the movie *Silent Running*, to the more familiar human-shaped figure of C-3PO in *Star Wars* (which in turn was based on the robot called Maschinenmensch in Fritz Lang's 1927 film *Metropolis*). Individuals that are part machine and part human are called cyborgs and share many characteristics with robots. Generally speaking, in cyborgs the machine parts are superior to the biological parts that they have replaced, giving them special or enhanced abilities. This demonstration looks at a robot design that is basically humanoid in form, and that is built for some sort of combat duty.

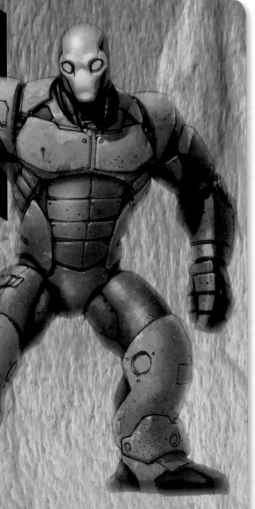

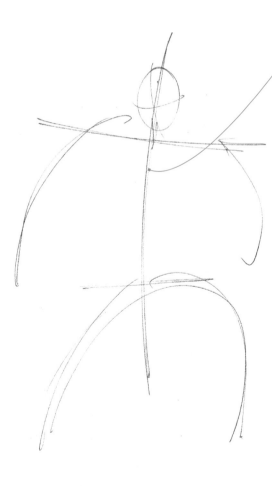

Draw the figure slightly off a perfectly vertical stance, to give him a dynamic attitude and a sense of personality.

Phase 1: Preliminary lines

Establish the line of action with a vertical line that represents the main stance of the figure, aiming for a sense that the robot is alert to its surroundings. Use a second almost horizontal line to determine the position of the shoulders. The rest of the drawing will be built on this foundation. On top of these marks, lay in a rough stick figure indicating the locations of its major landmarks such as the head, hips and limbs.

Phase 2: Basic forms

Begin fleshing out the character by indicating the simple geometric forms of the various parts of the body (see pages 18–21). This is the stage where you work out the fundamental proportions of the character. Remember that while bodies can be broken down into basic shapes such as cylinders and cubes, it's useful to add some twists and curves to the forms to emphasize the rhythm that you set up in your initial sketch. Notice that the cylinders forming the arms and legs – as well as the boxes forming the torso, hands and feet – taper slightly as they approach the extremities of the body, as they would in a human being.

Give the cylinders a very subtle curve along their lengths to reinforce the 'flow' of the limbs.

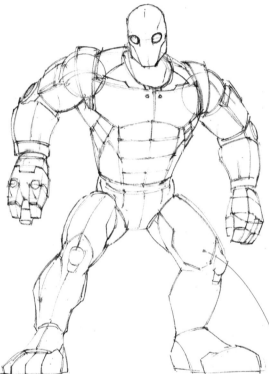

Phase 3: Shape refinement

Using a piece of tracing or parchment paper laid on top of the basic forms drawing, start refining and modifying the geometric shapes. Think about how one form makes its transition into another, paying special attention to the joints. In the human body, the knee and elbow joints behave like a hinge moving more or less in one axis. At the shoulders and hips, the limbs are connected with ball-and-socket joints, which allow movement in many directions. In your sketch, reinforce these ideas with shapes that indicate the type of movement the joint needs.

The overall silhouette is the most important 'message' in the drawing – the details need to support and be subservient to the silhouette.

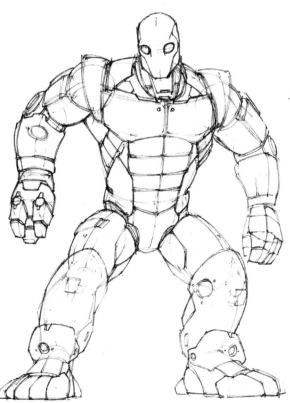

Phase 4: Initial detailing

Start layering on the smaller-scale details. The design of this mechanoid closely mimics a bipedal, humanoid body. By contrasting this with hard-edged, mechanical detailing you can emphasize the 'roboticity' of the character. The main strategy here is to break down some of the larger shapes into smaller ones using panels and cut lines. These panel shapes should roughly correspond to the contours of the larger muscles in the human body. At the joints, and at certain places in between the body panels, add some hint of cables, gears and smaller mechanical parts to convey the idea of a layered structure – armour plating on top and moving parts protected underneath.

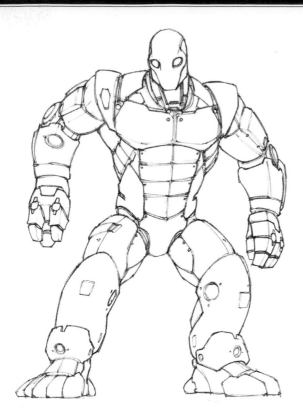

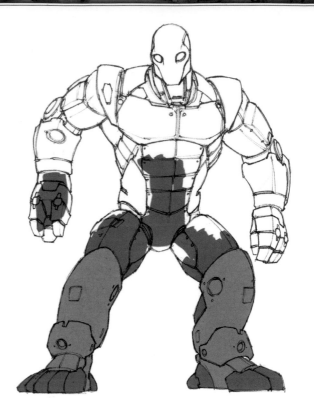

Phase 5: Final line art

If you are working traditionally, transfer the drawing to your final media using a light box. If you are working digitally, scan the image and use the Levels tool to create a clean line drawing (see page 16). Double check the image in reverse (either using the Flip Canvas command or by checking the drawing in a mirror) to see it from a different perspective and check for mistakes.

Phase 6: Colour initiation

Begin the colouring process by blocking in flat, medium-value colours using your preferred brush. Shading, shadows and highlights will be added later – for now you are just establishing the basic colour scheme for the design. Colour choices at this stage can begin to indicate a specific material palette – using a yellow associated with construction vehicles and a neutral grey for unpainted metal areas creates a sense of industrialism.

TIP: BLOCKING IN FLAT COLOUR EFFICIENTLY

When beginning to colour your image, try to work as efficiently as you can to get the flat colours blocked in. This is a preliminary stage and should be done as quickly as possible to allow you to spend more time on the rendering, but it also needs to be done cleanly and accurately. The best way is to paint around the outline of the shapes carefully then you can flood them with colour without worrying about making mistakes. When working digitally, considerable time can be saved using the Lasso tool to select areas then the Paint Bucket tool to fill the selected sections with colour.

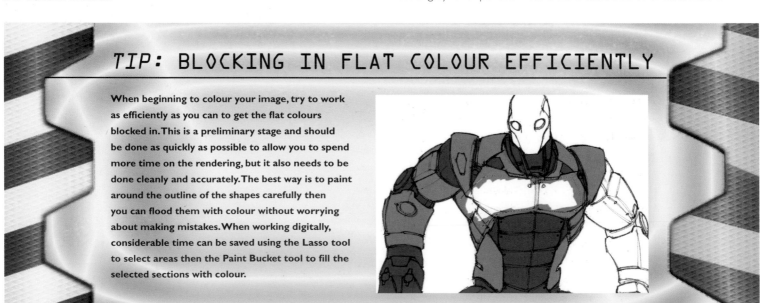

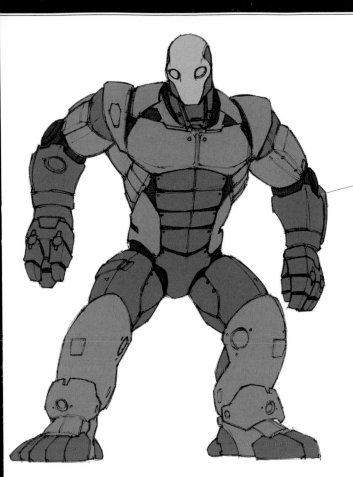

Phase 7: Block-in finalized

This image shows the completed flat colour block-in stage. Notice how the colours chosen for the different areas of the body work with the line art details to convey the idea of different functions and materials. The idea with this is that the light grey colour will indicate an unfinished metallic surface, and the yellow areas are painted metal surfaces. These two surfaces will exhibit different kinds of wear and tear, which will be added later.

Paint the robot in a two-tone grey and yellow colour scheme, and use a dark blue-grey colour to indicate areas where there are more mechanical details and moving parts.

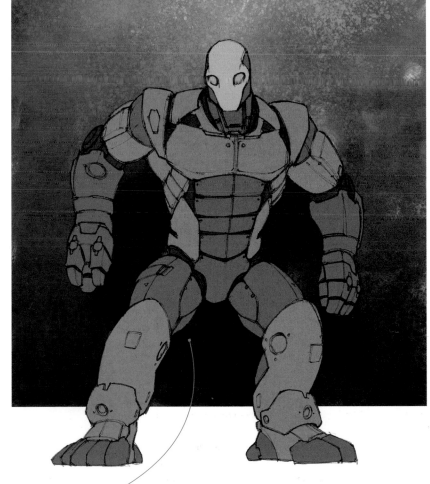

Phase 8: Background creation

When illustrating a character with no environment, it is often useful to add a neutral, medium-value background to help ground the character and eliminate the 'floating in space' feel. Define a rectangular shape that frames the upper part of the character's body, and use a square brush to paint in a rough medium-tone background using some of the colours from the robot, but with a slightly darker value. Introduce some texture by using different textured brushes or by splattering the area with slightly lighter and darker variations of the colours. Stop the background short of the feet to avoid confusing the issue of where he is standing – if the background were extended down to his feet, it would appear as if he were standing on the same material that the wall is made from, creating visual ambiguity.

Add a suggestion of cast shadow using a cool blue-green colour to help make the character stand out from the background.

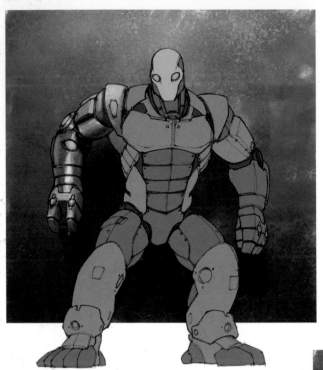

Phase 9: Rendering begins

Once your colours are blocked in you can start rendering – the main things to keep in mind at this stage are the lighting direction and the nature of the materials. The light source is above and to the left, and the forms will react to this in different ways. The round forms will have highlights that gradually fade to darker values as they turn away from the light source. The rectangular forms will have sides facing the light and sides that are in shadow, and will therefore have more distinct edges between different values. Lay in the smooth transitions on the curved, cylindrical shapes using a dark grey-blue colour and light blue-white for highlights along the centre of the cylindrical forms. Paint the more defined transitions with hard-edged brushes. Start playing around with textures such as scratches, dents and dirt or oil stains using a small-diameter brush. Rather than using white, use a light bluish-grey to indicate the shade of the metal surface underneath.

Phase 10: Further detailing

At this stage you should mainly be concerned with details, but it's a good idea to 'zoom out' frequently and study your image as a whole. It's easy to get too lost in detail and risk spoiling the overall colour/value design of the image. As you work on the painting, look at the entire image regularly to make sure the shading/highlight/material rendering is not calling undue attention to any one area. Continue to work on the colour rendering using the strategy outlined in the previous phase. Be consistent in the ways painted surfaces Vs bare metal surfaces, cylindrical Vs rectangular shapes, and flat panels Vs mechanical details ('greebles') are rendered.

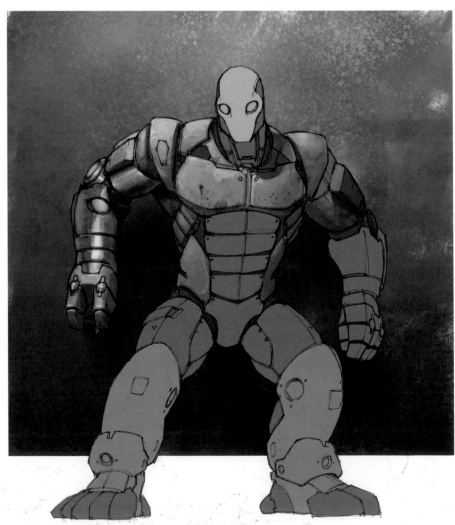

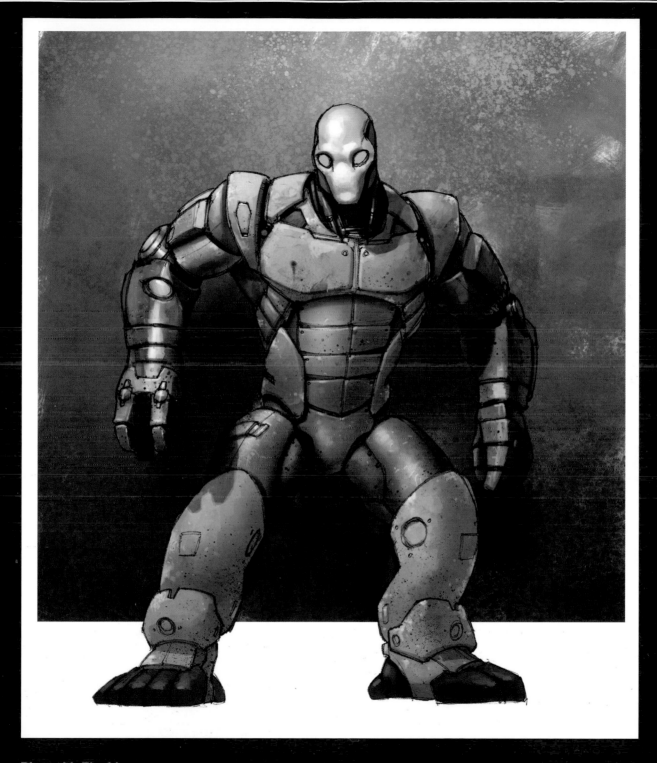

Phase 11: Final image

Finalize the illustration by indicating spots of cast shadow based on the direction of the main light source. Here, the main light source is above and to the left of the character. The right side (his left) is in shadow, and you can see shadows being cast on the leg and opposite forearm. The final image shows a character that is obviously mechanical and robotic in nature, but whose body design shows a rhythm and fluidity that is based on the human figure. With heavy-duty construction and stocky proportions, he is perfectly designed for his duty as a combat robot and would be a tough opponent in battle.

TRANSPORT

speeders, spinners and spaceships

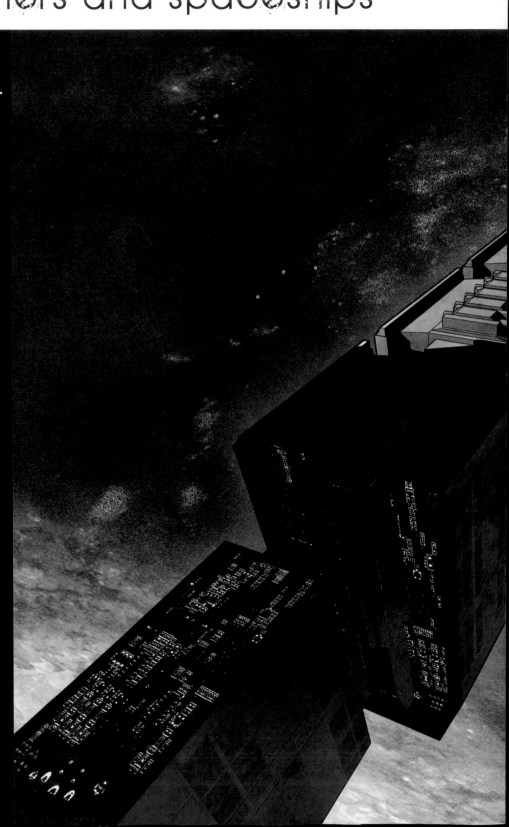

Technology has always played a major role in the visual interpretation of science fiction. Early science-fiction films and television shows might not have had sufficient special-effects expertise to keep up with the imagination of the creators, but the concept of futuristic advanced technology was always there. This typically took the form of weapons and vehicles, as these are indispensable ingredients of all adventure stories, science fiction or otherwise.

Science fiction is unique, however, in creating a need for large-scale vehicles for travelling through space. These spaceships almost create a new category of technology, somewhere between vehicle and architecture. Examples of this are the USS Enterprise in *Star Trek*, or the gigantic Death Star in *Star Wars*.

The following demonstrations look at some examples of vehicles that might be found in science-fiction scenarios, ranging from a wheeled vehicle that could appear on earth in just a few years' time, through a single-pilot fighter craft designed for space combat, to an epically scaled space cruiser.

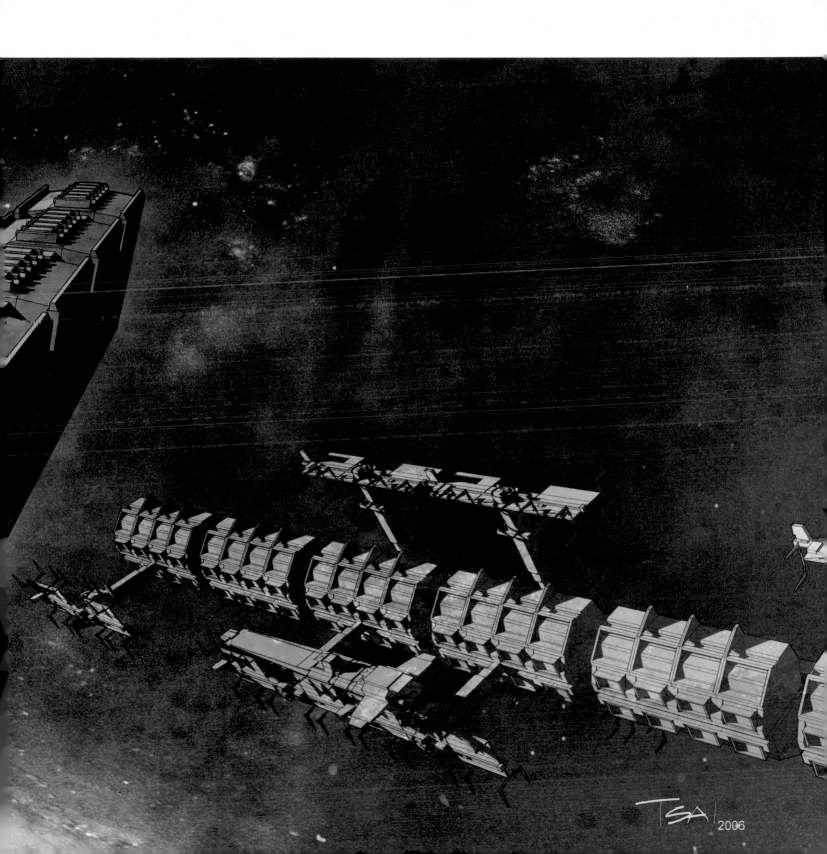

spaceship

As much of science fiction occurs in outer space, it is only natural that spaceships are at the heart of intergalactic life, giving people a way to move around and exist in the deepest reaches of space. Spaceships are one of the primary ways in which science fiction is unique compared to other entertainment genres, and are therefore one of the most exciting challenges for the sci-fi illustrator. The visual design of spacecraft can range from traditional vehicle design (such as Luke Skywalker's landspeeder in *Star Wars*) to large-scale, almost architectural or environmental designs (such as the Cylon Basestar in *Battlestar Galactica*), or anywhere in between. This exercise shows you how to create an epic, monumentally scaled battle cruiser in the tradition of the space opera.

Phase 1: Geometric forms

Start your image by laying down a few basic geometric forms (see pages 18–19). Give your ship a tall pyramid-like form, with some secondary geometric shapes added on to provide some interest. Establish a fairly straightforward, head-on camera angle, as if the craft is approaching the viewer from almost directly ahead.

Angling the ship very slightly to the right of the viewer will allow you to introduce some perspective later.

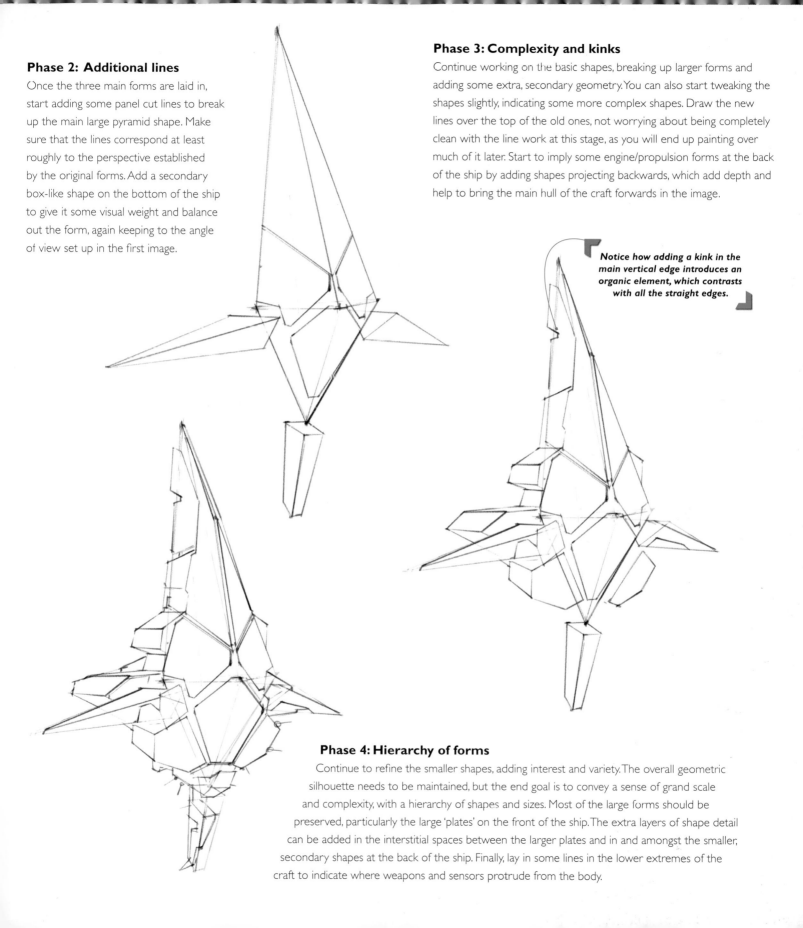

Phase 2: Additional lines

Once the three main forms are laid in, start adding some panel cut lines to break up the main large pyramid shape. Make sure that the lines correspond at least roughly to the perspective established by the original forms. Add a secondary box-like shape on the bottom of the ship to give it some visual weight and balance out the form, again keeping to the angle of view set up in the first image.

Phase 3: Complexity and kinks

Continue working on the basic shapes, breaking up larger forms and adding some extra, secondary geometry. You can also start tweaking the shapes slightly, indicating some more complex shapes. Draw the new lines over the top of the old ones, not worrying about being completely clean with the line work at this stage, as you will end up painting over much of it later. Start to imply some engine/propulsion forms at the back of the ship by adding shapes projecting backwards, which add depth and help to bring the main hull of the craft forwards in the image.

Notice how adding a kink in the main vertical edge introduces an organic element, which contrasts with all the straight edges.

Phase 4: Hierarchy of forms

Continue to refine the smaller shapes, adding interest and variety. The overall geometric silhouette needs to be maintained, but the end goal is to convey a sense of grand scale and complexity, with a hierarchy of shapes and sizes. Most of the large forms should be preserved, particularly the large 'plates' on the front of the ship. The extra layers of shape detail can be added in the interstitial spaces between the larger plates and in and amongst the smaller, secondary shapes at the back of the ship. Finally, lay in some lines in the lower extremes of the craft to indicate where weapons and sensors protrude from the body.

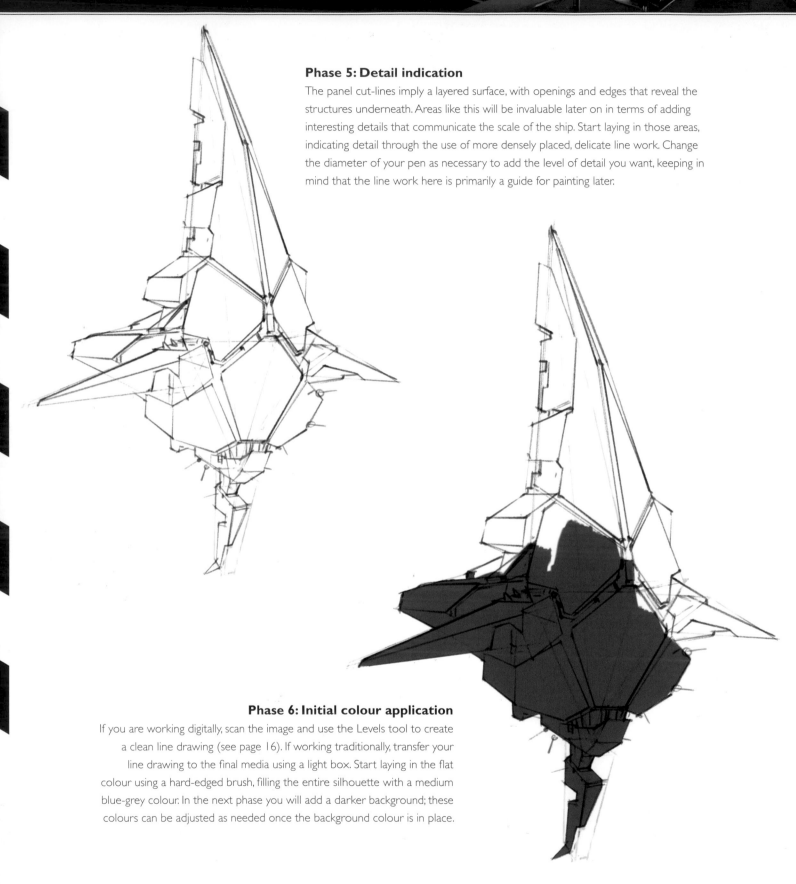

Phase 5: Detail indication

The panel cut-lines imply a layered surface, with openings and edges that reveal the structures underneath. Areas like this will be invaluable later on in terms of adding interesting details that communicate the scale of the ship. Start laying in those areas, indicating detail through the use of more densely placed, delicate line work. Change the diameter of your pen as necessary to add the level of detail you want, keeping in mind that the line work here is primarily a guide for painting later.

Phase 6: Initial colour application

If you are working digitally, scan the image and use the Levels tool to create a clean line drawing (see page 16). If working traditionally, transfer your line drawing to the final media using a light box. Start laying in the flat colour using a hard-edged brush, filling the entire silhouette with a medium blue-grey colour. In the next phase you will add a darker background; these colours can be adjusted as needed once the background colour is in place.

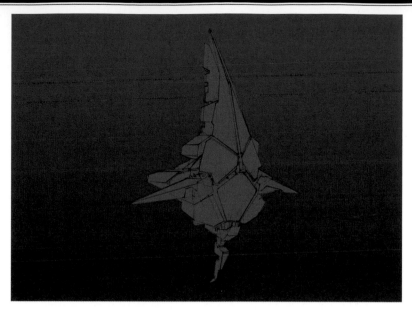

Phase 7: Background creation

Finish blocking in the medium-tone flat colour then lay in a subtle blue-purple gradient as a simple background, picking up colours related to the spaceship and which seem appropriate for an outer-space environment. Keep the value of the background gradient slightly darker than the medium value of the spaceship. Lighter and darker values will be added to the body of the ship later; keeping the background somewhat darker will help convey the sense of the craft floating in outer space.

Phase 8: Lighting direction

Establish a location and direction for the main light source. In reality, light intensity in space is not affected by atmosphere like it is on earth. For the purposes of this illustration you have to cheat a bit and model the behaviour of light as if there is an atmosphere present. This allows you to use atmospheric perspective (the phenomenon that makes objects appear greyer and fuzzier the further away they are) to convey scale and distance. Select a main light source somewhere directly above the craft, and begin modelling the ship by darkening the surfaces that face away from the light source, using a square brush and large brushstrokes. Choose a very dark blue colour but not absolute black to indicate the joint lines between the main panels of the ship.

Don't worry about perfectly blending the colours to get a smooth transition; the visible strokes actually add some visual interest and can be used later as the basis for added texture.

Phase 9: Texture and light

Work on adding some textural quality to the panels on the ship, creating some 'accidental' marks with random brushstrokes (see Tip, below). Try to lose some of the hard edges by blending the transitions between darker and lighter areas. However, too many 'lost edges' will make the illustration appear blurry and indistinct. Pick up some of the purple from the background gradient and use it to paint into the darker, downward-facing surfaces on the ship. This helps to give the ship a more three-dimensional quality.

Phase 10: Important scale details

Start adding some of the details that convey a sense of scale. Use a fairly bright colour, such as a bright yellow-green to indicate lit windows and portals. Keeping the windows restricted to the dark areas in between the panels emphasizes the 'layered' design concept. The large panels act as an armour plating and the utilities, mechanical systems and window openings are located underneath and can be seen where the armoured panels separate. Use a low-opacity airbrush to add a pale-yellow glow to the windows. If necessary, go back over the window areas with a brighter yellow to pump up the light sources.

TIP: CREATING IMPERFECTIONS

Deliberate imperfections in your work make for a more dynamic image. When working traditionally, don't be tempted to paint over every flaw; these are worth having as they give your images more interest. When it comes to digital art, the tendency is to make everything as smooth as possible, but this can get a little boring visually. It is actually more difficult with digital tools than with traditional media to get those 'happy accidents', so it is worthwhile introducing them on purpose to keep your illustrations fresh and exciting.

Phase 11: Continuation of detailing

Continue adding the fine-grain details. Use highlights and shadows on some of the noise and marks from your random brushstrokes to indicate dents and divots in the metal panels. Also, add linear highlights along edges where the panels bend and change direction, and along the guns, sensors and other protuberances. Using the same brush, paint some light blue highlights on any upward-facing surfaces and edges, and also where a flat surface changes planes and forms an edge.

Phase 12: Final image

Continue to add highlight and texture details across the rest of the ship. Adding a glow effect to the main windows at the centre of the ship with a quick hit of the airbrush is another atmospheric effect that can add some visual interest. Keeping intricate detail to a few key areas communicates the epic scale of the craft, while the easily readable shapes convey the three-dimensional form of this giant spaceship, without drowning it in detail.

land vehicle

Wheeled vehicles often seem like vestiges of a past age in science fiction. In all of the *Star Wars* films, there are only a handful of vehicles that have wheels. Even on a planet's surface, private vehicles usually take the form of small hovercraft, like Luke Skywalker's landspeeder. Some science-fiction vehicles, such as the police spinner in the film *Blade Runner,* are evolutions of standard vehicles – the wheels have been replaced with an anti-gravity device that allows them to become airborne. In some scenarios however, such as those set in the near future, wheeled vehicles will still be appropriate, being more or less updated versions of the cars or trucks we see today. This demonstration shows you how to design and illustrate a utility vehicle that is used to transport large robots. Creating this illustration will involve the techniques of rendering metal and differentiating between reflective and non-reflective surfaces.

Phase 1: Basic geometry

The basis for this sketch is a simple, one-point perspective drawing (see page 22). The vehicle is a geometric design consisting of two main boxes – one vertically oriented box forms the driver's cabin and a second long, horizontal box forms the cargo area. There are also some smaller boxes and cylinders, which make up the secondary forms and details of the truck. Use a 10 or 20 per cent grey marker to lay out the perspective guidelines quickly, and rough in the two major box forms. Don't worry about being too precise at this stage, as this will only be used as an underlay from which to trace the final line work.

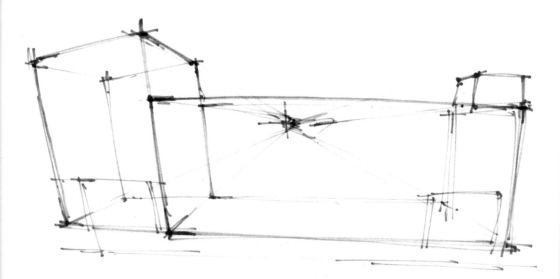

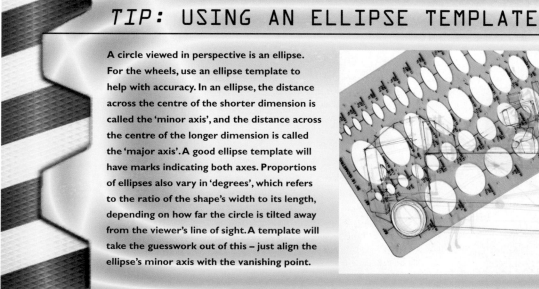

Phase 2: Secondary forms

Continue working on the marker sketch, adding some of the smaller shapes and forms that identify the different parts of the truck, such as wheels, cabin and running lights. Keep the lines loose and sketchy, and take the opportunity to explore different variations in the placement of lines, angles and graphic shapes. Sketch a rough outline of the robot in the bed of the truck. The size of this robot is much larger than a human being, and so the addition of a human figure visually communicates the sense of scale to the viewer. Add some indication of the cables and rigging that secure the robot in a standing position.

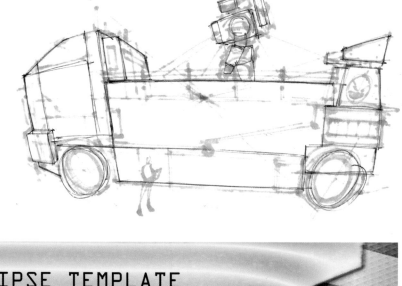

Phase 3: Line work refinement

Take a piece of tracing or parchment paper and lay this over your marker sketch to create the final line art, using either a mechanical or regular artist's pencil. This step requires some judgment and editing – choose the lines in the rough sketch that most accurately depict the forms. In my opinion, it's better to avoid using a straightedge for this if possible – giving the long edges a small amount of curvature adds some dynamism to the line, and creates a subtle fish-eye lens effect.

TIP: USING AN ELLIPSE TEMPLATE

A circle viewed in perspective is an ellipse. For the wheels, use an ellipse template to help with accuracy. In an ellipse, the distance across the centre of the shorter dimension is called the 'minor axis', and the distance across the centre of the longer dimension is called the 'major axis'. A good ellipse template will have marks indicating both axes. Proportions of ellipses also vary in 'degrees', which refers to the ratio of the shape's width to its length, depending on how far the circle is tilted away from the viewer's line of sight. A template will take the guesswork out of this – just align the ellipse's minor axis with the vanishing point.

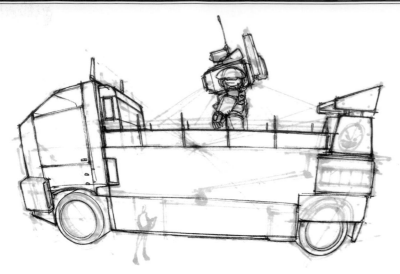

Phase 4: Line drawing completion

Continue laying in the line work for the major components of the truck and also for the robot in the truck bed. The pencil drawing should be more refined than the initial marker sketch, but some looseness and sketchy quality in the line work is fine at this stage. Some of the lines can be darkened, making the specific shapes and details of the vehicle more apparent. In some instances, having two or three lines that run closely parallel (such as between some of the body panels) can imply details such as edge trim, or indicate transitions between different materials. Some of this 'line doubling' around the edges of the cabin windows can indicate weather strips or protective gaskets, creating an air of precisely manufactured machinery.

Phase 5: Final drawing clean-up

Set aside the marker layout drawing and work on refining and cleaning up the pencil drawing. Darken the line work that most accurately delineates the form, and use a kneaded eraser to remove some of the more erratic stray lines. Add the last layer of detail, indicating panel lines, rivets, graphics and so on. If you are working digitally, scan the drawing and bring it into your preferred digital painting program then clean it up using the Levels tool in preparation for applying colour (see page 16). If you are working traditionally, transfer the drawing to your final media using a light box.

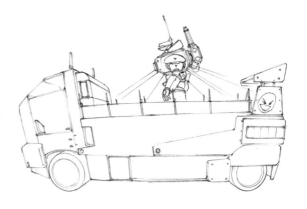

Phase 6: Base colours block-in

The truck consists primarily of two different materials – a reflective, light blue metal and a more matt grey rubber/synthetic material. The robot is constructed mainly of metal with inner mechanicals and equipment made of darker, non-reflective metals, rubber and synthetics. The metal of the robot will be much less glossy and reflective than that of the truck, as it has seen some wear and tear. For now, just establish the medium colours for the main areas of the image; the specific lighting and rendering of the materials will come later. For the environment, rough in some flat-topped mesas to indicate a desert-planet setting.

> *Make sure that the horizon of the background corresponds to the horizon line established in the original perspective drawing.*

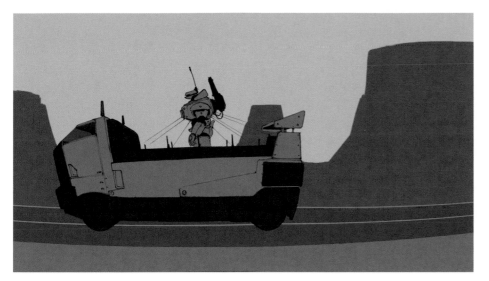

Phase 7: Road surface

You now have a landscape, but the bare ground seems a strange place for the vehicle to be resting. Adding a roadway seems more appropriate, and helps to reinforce the concept of a wheeled vehicle. Using a hard-edged, medium-sized brush, paint in a cool dark-grey shape with a slight curve to give a subtle fish-eye lens effect, so that it matches the wide-angle view of the vehicle. Using a small-diameter, hard-edged brush, add some yellow markings to help communicate the idea of an artificial road surface. Follow the general shape and curve of the road as closely as possible, although just as in real life a tiny amount of imprecision is OK.

Phase 8: Scale figures

The initial marker sketch included a figure to indicate the scale of the vehicle and the robot. This is an important visual cue that needs to be brought back into the drawing now. As well as communicating the scale, showing figures interacting in the scene also provides an opportunity for storytelling. Give one of the two characters a clipboard, as if they are discussing a cargo manifest or verifying a destination. Go back to your original drawing and use a new piece of tracing or parchment paper to add the driver and assistant. Then, trace them on to another piece of paper, scan them and add them to the image on a new layer. If you are working with traditional media, paint the figures directly on to the image using an opaque medium such as gouache or acrylic.

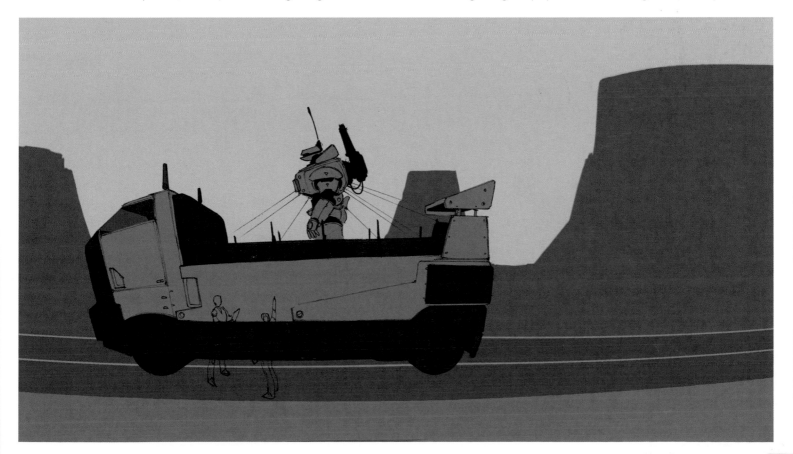

Phase 9: Lighting and rendering

Establish the main light source directly overhead, with a warm colour temperature appropriate for the setting. The most brightly lit surfaces will be those that are facing upwards. Most of the truck's surfaces are facing the viewer, away from the direction of the light, so they will remain essentially the same value as in the original colour block-in. On the robot, most of the upward-facing surfaces are visible to the viewer, such as the top of the shoulder epaulet, upper arm and forearm. The epaulet casts a shadow on the upper arm segment, and thin, highlighted arcs of upward-facing surfaces can be seen on top of the head and chest volumes. Add some subtle modelling and atmospheric perspective (see page 69) to the mesas with a light blue colour.

Phase 10: Reflections – Part 1

The main body panels of the truck are made of glossy painted metal, like most cars today. This kind of highly reflective material exhibits a certain predictable behaviour in terms of how it interacts with light and the environment. The first step is to create a pattern of reflection that represents the ground and environment around the truck. The main components of the pattern are the horizon and the ground. The surface of the truck facing the viewer will reflect the horizon far behind us, and as the surface curves gently inwards towards the bottom of the truck, more of the ground will be reflected. Start working on the reflection patterns by painting in a gradient of dark blue at about the horizon level that fades out to the local colour of the truck body.

The reflection pattern should only appear on the blue metal portions; the other materials will not reflect light in the same way.

Phase 11: Reflections – Part 2

Use the same logic and technique as in the previous phase to finish the reflection in the side of the truck. Add some very light blue-green to the top part of the truck's cabin. This represents the metal surface reflecting the light from the sun and sky. Pushing the colour into the greens indicates some warm colour temperature from the sun (yellow + blue = green). Carefully draw in simple reflections of the characters in the side of the truck using a small-diameter, hard-edged brush. To ground the truck in the scene a little more, add in the cast shadow from the truck and crew using a cool, dark grey-blue and a hard-edged brush to approximate the crisp desert-planet lighting conditions.

Phase 12: Final image

Finish rendering the truck using the same lighting scheme to render the matt grey rubber parts. This material is not as shiny and reflective as the metal, and so the colours of the atmosphere will not affect it as much. Slightly brighten the upward facing surfaces and darken the downward-facing ones. Highlight the edges and corners of the material using thin lines of very light blue. Add some of this light blue colour to the upward-facing edges of panels and indentations to brighten these surfaces slightly. Add some spots of bright blue-green with a medium, hard-edged brush to indicate running lights on the truck. Finally, add a wash of light yellow/brown over the whole image, as if the scene is being bleached by the harsh sunlight of the desert planet.

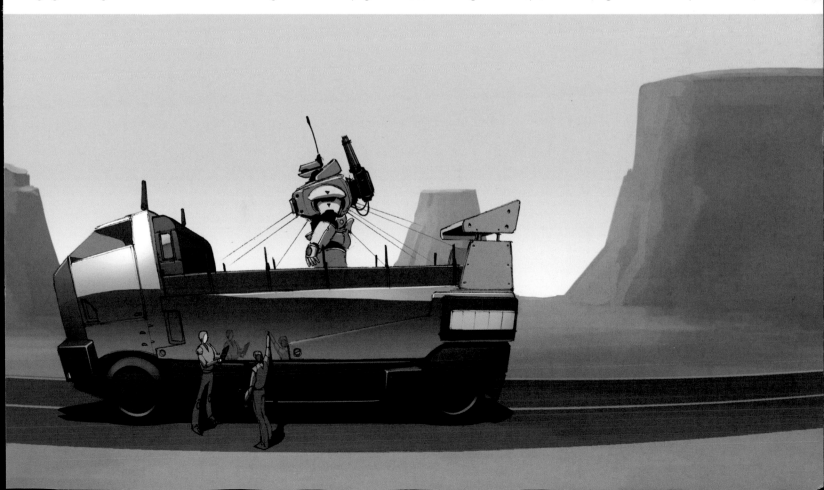

space fighter

Films and television shows such as *Star Wars* and *Battlestar Galactica* have popularized the idea of aerial dogfights taking place amongst small, highly manoeuvrable single-person fighter spacecraft, inspired by the air-to-air combat of World War II. In science fiction, physics usually takes a back seat to visual appeal, in both action and design. The great thing about this is that it allows illustrators to appropriate certain visual cues from existing aircraft, helping to convey the image of a small, agile, heavily armed ship using visual vocabulary that people are already familiar with, but also to have fun with the design of the craft, without worrying about the constraints of real-world science. This demonstration will show you how to illustrate an exciting space fighter ship, moving at high speed with guns and thrusters blazing. Design-wise, the ship consists primarily of engines and weapons, with a small cabin space for the pilot.

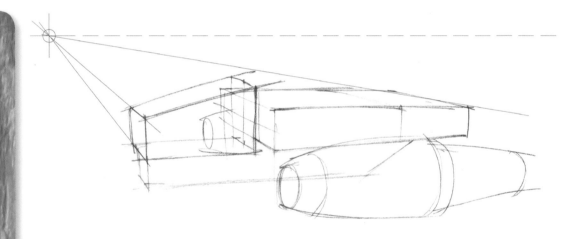

Phase 1: Basic shapes

Design the ship as a combination of guns and engines to emphasize its utilitarian nature as a fighting machine. Begin with a red pencil on a piece of tracing or parchment paper and lay out the basic forms as three boxes and two tapered cylinders, using a rough two-point perspective view (see page 23). The left vanishing point is above and to the left of the cabin (shown as a circle on the image) and the right vanishing point is off the page, but is located on the same horizon line (indicated by a dashed line). Use cylinders to represent the exhaust thrusters and a large central box to contain the reactor or main guts of the engine. Draw a smaller tapered box at the front to house the pilot and a longer box underneath to indicate the placement of the main weapon.

Phase 2: Visual identity

Using the basic forms as a guide, begin refining the shapes. Introduce a more fluid, organic shape to the canopy, creating a rounded cross section. Create an angled boxy shape just under the nose to contrast with the organic shape of the canopy and hull and to house the main gun. Continue the curvature of the hull underneath the cabin and behind the weapon. Add some secondary shapes to the reactor section, adding intakes and secondary manoeuvring thrusters. It's important to remain loose in these first few steps, to allow yourself to explore the subtleties of form and curve in the ship's design.

The contrast between the curves of the body and the angularity of the weapon creates a nice visual emphasis.

Phase 3: Line work refinement

Switch to a normal lead pencil and start picking out the forms in a more precise manner, choosing from the sketch lines laid out in red. The lines across the short dimension of the fighter ship should converge on the nearer vanishing point, above and to the left of the ship. The vanishing point on the right is very far off the page, which will require some visual approximation. Start laying in the next layer of details, still being fairly loose and expressive. Add in some panel lines, vents and intersecting volumes in the reactor section.

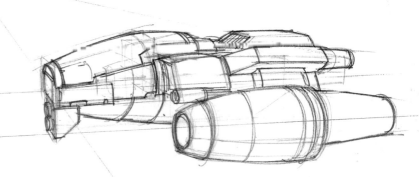

Phase 4: Details

Continue adding interesting details such as exposed mechanical systems, external sensors, vents and heat exchangers, working evenly across the ship. Start adding some visual vocabulary borrowed from familiar sources — looking at weapons on helicopter gunships can provide some interesting reference. The reactor section borrows its form language from automobile engines, such as cylinder head covers and exhaust manifolds. Finally, add some exhaust flaps on the back end of the ship to balance the ship visually and relieve the somewhat 'stubby' feel of the design.

Avoid spending too much time on any single area; try to keep an overall impression of the ship in your mind's eye so that the design remains balanced.

TIP: KNOW YOUR GREEBLES

'Greebles' is a term used by industrial designers and illustrators to generically describe the detailed, complex-looking mechanical elements that are used to add visual interest and complexity. The form language of greebles borrows heavily from familiar sources such as automobile engines, modern weapons, electronic components, plumbing and other highly engineered, complex utilitarian objects. Creating science-fiction illustrations will undoubtedly require a large vocabulary of greebles, so maintaining a collection of inspirational images of these types of objects can be a valuable resource. The greebly details in the engine in this fighter ship borrow some visual elements from the engine bay of a V8 Mustang.

Phase 5: Final line work

On a new piece of tracing or parchment paper laid over the sketch, lay out the final line work with an ink pen. Try to avoid using a straightedge for this stage; slight irregularities will preserve some of the hand-drawn quality of the line art. However an ellipse template can be useful for any circular parts of the hull and engines (see Tip, page 73). In this phase, last-minute details such as bolts, warning graphics, vent strakes and other greebles (see Tip, above) can be added.

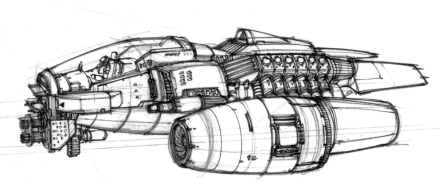

Phase 6: Preparation for painting

If you are working digitally, scan the final ink drawing into the computer and open it in your painting software. Use the Levels tool to clean up the drawing and replace the paper colour with a white background in preparation for colouring and rendering (see page 16). If you prefer to work traditionally, transfer your line drawing to the final media using a light box.

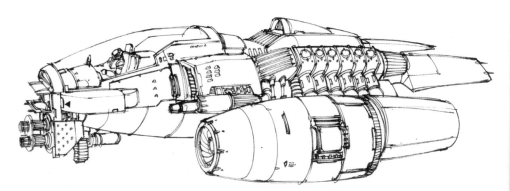

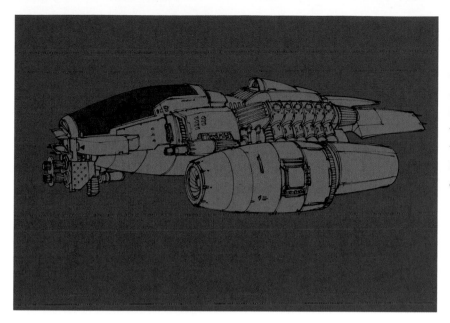

Phase 7: Basic colour block-in

Start blocking in the colour scheme, filling the background with a blue-grey colour and the ship with a lighter, warm medium-grey. Give the canopy a darker warm-grey. The colours of the ship are chosen to portray an industrial metal primer colour, emphasizing its functional nature and also providing a nice temperature contrast with the background. Use a round, hard-edged brush to fill in the flat areas of colour. If working digitally, remember that using the Lasso and Paint Bucket tools to fill large areas can save time and effort (see Tip, page 60).

Phase 8: Function differentiation

Use a dark, neutral grey to call out the mechanical and utility areas such as engines and weapons and various exposed greebles. Leave the warm grey from the previous phase to represent hull plating and fairings. At this stage you are still concerned with blocking in only the flat colours.

Add a different colour to sections of the ship to visually distinguish the functions of the individual parts. This will help the viewer understand the design more easily.

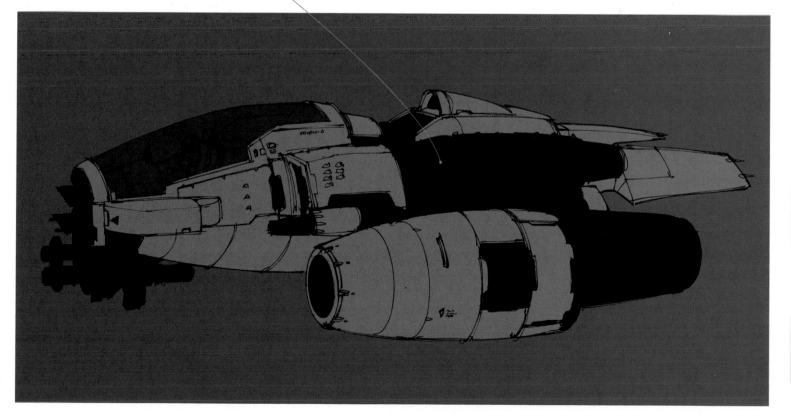

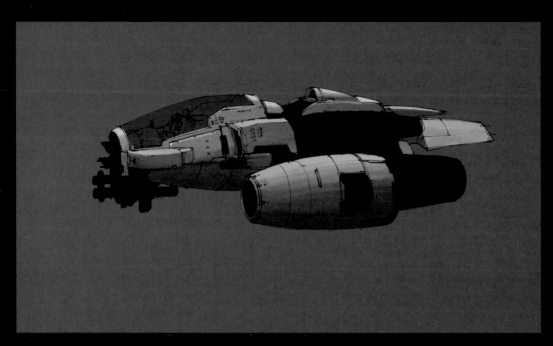

Phase 9: Lighting

Start modelling the ship with lighting, using a warm, bright-yellow light source directly overhead. The cylindrical forms will be lit on the top surfaces and gradually darken as their forms turn away from the light source. Flat surfaces get brighter if they are facing the light source, or darker if they are facing away from it with much harder transitions between values. The metal surface is somewhat shiny but not reflective like polished metal or chrome; as the surfaces orient more directly to the light source above, the material will brighten to a very light warm-grey.

Phase 10: Lighting continued

Use the same approach as described in the previous phase on the darker-coloured functional portions of the ship. Because these parts are made of more polished, reflective materials than the primer-painted surfaces of the hull, these areas will tend to be shinier with more concentrated highlights. The details and greebles will have sharper, brighter highlights than the lighter-grey body panels of the ship; these highlights can be painted using a small-diameter, hard-edged brush. Next, block in the silhouette of the pilot and cabin instruments. Not a lot of detail is needed here, as a reflection on the glass of the canopy (which will be added in the next phase) will obscure much of the interior.

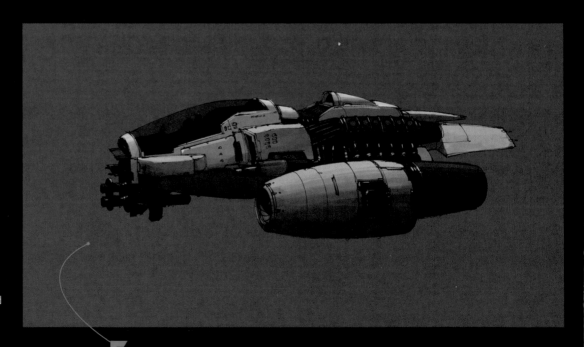

Creating visual interest and appeal is often a case of engineering attention-grabbing contrasts of shape, colour and detail. Interrupting the smooth silhouette of the hull with small areas of complex detail results in a more dynamic image.

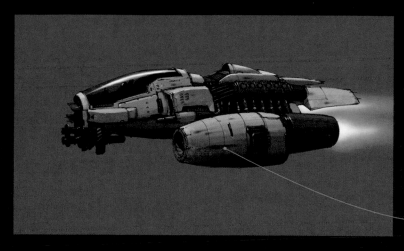

Phase 11: Final detail pass

Add the chips, dents and scorch marks using an airbrush and a small-diameter textured brush, then paint in some caution stripes and warning labels near the cockpit. Add some subtle highlights to the pilot and his instruments using a medium-value blue to suggest that the glass is tinted. Using a hard-edged airbrush, add a reflection of the light source to the canopy in yellow-white. The edge of the hull will be reflected too, so use a darker version of the hull colour to indicate this. Paint in the thruster exhaust, starting with a gradient of yellow-white for the hottest part at the centre, blending to an intense orange at the edges.

Align the weathering effects and scorch marks with the direction of travel of the ship; attention to details such as this helps create a convincing sense of reality and adds to the narrative of the image.

Phase 12: Final image

Create a blurred star field behind the ship to indicate speed. If working traditionally, paint these with an airbrush. In a digital program, paint in the shapes then apply horizontal motion blur. A mild gradient with a warmer, brighter colour in the centre along the ship's direction of travel will add to the feeling of motion. To enhance the action, add some weapons-fire effects at the front of the ship using a small-diameter airbrush, going from a hot yellow-white in the centre to orange at the edges. Finally, using a medium-sized, hard-edged brush, add a semi-transparent wash of yellow-orange colour to sections of the main engine pod in the foreground; this adds an element of custom marking to the ship, perhaps indicating membership to a specific squadron.

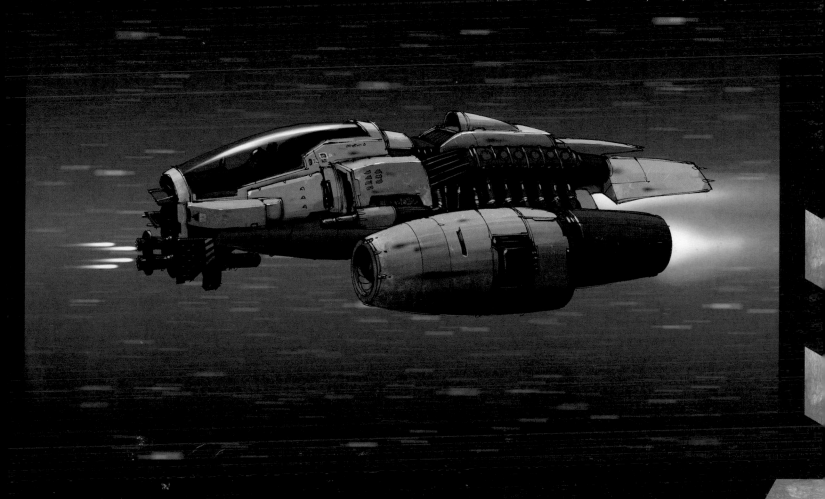

ENVIRONMENTS
earth and beyond

Environment design in science fiction is often an exercise in extrapolating current trends in architecture, interior design and engineering to various points in the future. In pessimistic scenarios, designers and illustrators will try to visualize what our current civilization might look like after some sort of cataclysmic event. In more optimistic situations, the task of the science-fiction artist will be imagining an alien world and its accompanying technology.

Technology is typically a key driver in picturing the environments of the future, whether it involves envisaging how humanity will invent new ways to create spaces and shelters, how an alien race builds and occupies its environment, or how a civilization – human or alien – will bring about its own destruction. Outer space is also a vital component of science-fiction imagery, and being able to convincingly depict it and the planets it contains is a core skill in a science-fiction artist's toolset. The demonstrations in this chapter look at effective ways to illustrate some of these kinds of environments.

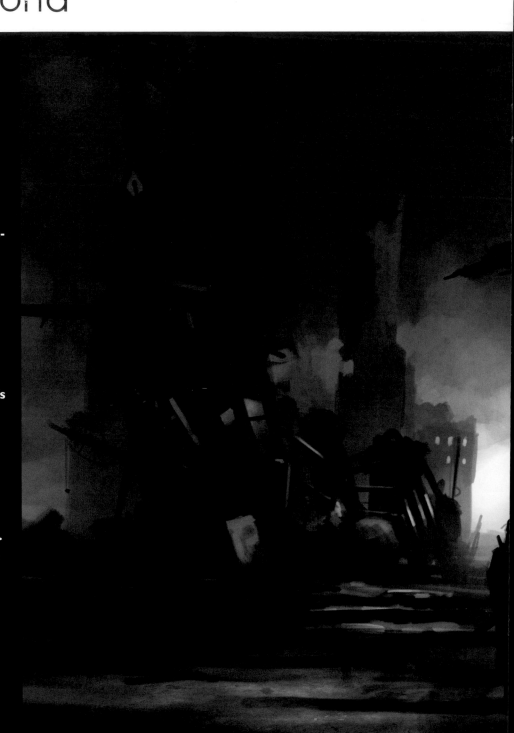

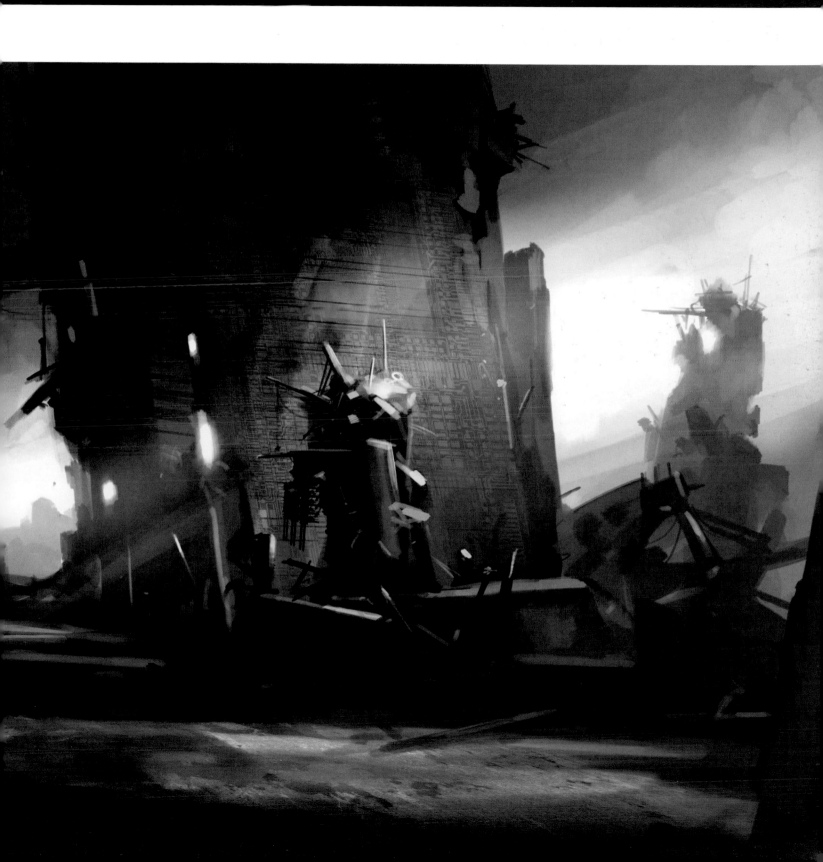

spacescape

As the 'final frontier', space is often the location for sci-fi stories. In creating illustrations with science-fiction subject matter, outer space will undoubtedly appear at some point as a setting or backdrop. Depictions of the cosmos can range from a simple dark sky with a scattering of pinpoints of light, to richly multicoloured atmospheric scenes, such as those taken from **NASA's Hubble Telescope**. Depending on what else appears in the scene, the outer-space scenery needed for an illustration might typically fall somewhere between these two extremes. This demonstration shows you how to put together a scene – almost a 'kit of parts' – containing a number of different elements that might appear in various kinds of illustrations. It starts with a black canvas and builds to a believable space scene full of distant stars and interstellar clouds.

Phase 1: Space

In reality, outer space consists of an absence of light. A pure black field seems rather dead for the purposes of an illustration though, so the first phase is to introduce a hint of colour, volume and movement to alleviate the flat feel of the black canvas. Begin with a very dark blue wash and then suggest some vague cloud-like forms in a range of lighter blues and purples. Use a large, soft-edged brush and keep the shapes subtle, indistinct and random. Vary the size and shape of the brushes you use to help create an arbitrary feel.

Phase 2: Light

Using a blend of more saturated blues and purples, carefully wash in a suggestion of a band of light across the scene. Introduce some colour temperature variation by brushing in some areas of very subtle orange and red; the effect should be a slight warming up of the blues and purples, rather than an obvious splash of colour. This type of effect might be observed closer to the centre of a galaxy: an accumulation of light from thousands of suns. To increase the sense of illumination in the central part of the scene, darken the top and bottom of the image with cool dark blues, again using large, soft-edged randomly shaped brushes.

Make the nebulae denser and more opaque near their centres, and fade them out towards the edges. Don't use a smooth fade though – a more natural effect can be created if you fade them in clumps with ragged edges.

Phase 3: Nebulae

Start adding some dark-coloured indistinct nebula cloud forms to the centre of the image to contrast against the central illuminated band. Use a combination of hard- and soft-edged brushes to create interesting and varied silhouettes in high-contrast areas, which fade into the ambient colours in the darker areas. Looking at references of real clouds is a good source of inspiration for this.

Phase 4: Stars

Continue experimenting with shapes and adjusting the silhouettes of the nebula clouds and the illumination in the background, aiming for a natural-feeling, unplanned quality. To enhance the cloud effects, brush in some more saturated and brighter colours along the edges adding some more intense light and colour. Switch to a small-diameter, hard-edged round brush and begin dotting in some bright, distant stars in white. Keep the distribution varied, implying some binary and even multiple star systems, and change the size and intensity of the stars as much as possible by adjusting the diameter of the brush and the transparency of the colour.

Phase 5: Stars continued

Carry on distributing the stars around the scene, making sure to preserve the sense of random distribution and light intensity. If you are working with traditional media, a good way to accomplish this is to load up an old toothbrush with a small amount of opaque white paint and using your thumb to spatter dots across the image. An airbrush or paint atomizer can also be used for this purpose. In a digital painting program, vary the size, scattering and opacity of the brush to achieve the same effect.

TIP: ADDING VOLUME TO THE CLOUDS

To give more depth to the clouds, add areas of brighter and more saturated colours around the silhouettes of the darker nebulae. This increases the contrast at the edges and implies a bright light source hidden behind the clouds. Vary the colours by selecting shades adjacent to the main colour on the colour wheel (see page 26) and add a very small amount of complementary colour. For example, the contrast between the dark cloud and the brighter blue area behind it is heightened by increasing the brightness of the blue, adding a few strokes of purple and some very light (almost imperceptible) strokes of orange, to warm the colour temperature slightly.

Phase 6: Constellations

Continue building up the star formations in the image. Adding variations in colour to the stars is another way to modulate their apparent intensity – darkening the stars using blues and oranges will make them appear dimmer and further away. Some of the nebula clouds will obscure the distant stars, so use large, soft-edged brushes to pick up some of the darker blue and purple colours and use them to wash out a few patches of the star field.

Phase 7: Novas and supergiants

To add some secondary focal points, paint in some larger, closer stars using a large-diameter round brush. Use an airbrush to add glows; these glows are typically darker than the bright centres of the stars. Some of these bright points might consist of stars going nova as they age and decay. This is appropriate in a scene close to the centre of the galaxy, where theoretically there might be a greater range of types and ages of stars and star systems.

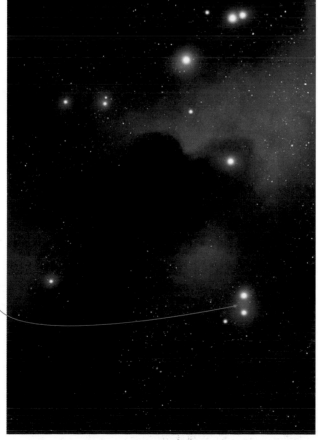

Avoid spacing the stars too evenly as this undermines the feeling of randomness. Cluster brighter stars with dim stars, and limit the number of very bright stars; these draw the eye and too many will reduce the overall impact.

Phase 8: Variations

Some of the brighter stars are in the process of expanding and losing their outer layers in the transformation to a supernova state. Increase the glow effect of some of these larger, more visible stars by adding some variations in colour and randomizing the shape slightly, elongating and distorting the glow. Introducing some variation to the shapes, by creating some oblong or streaky patches, can imply material being flung away from the star due to centrifugal forces.

Phase 9: Nebulae revisited

Up to this point the nebulae have been left as silhouettes, with no lighting acting on them. Introduce a gentle warm light from somewhere above. Using some of the large, soft-edged, randomly shaped brushes used earlier, lightly paint in similar shapes of deep yellow and orange. Always think of cloud forms as three-dimensional shapes, with volumes that react to light sources and that cast shadows. Treating these nebulae as normal clouds is a slight exaggeration, but it is one way to create interest using a visual analogy that people are familiar with. Using easily understood lighting and shadow cues will help give the clouds physical form. Again, refer to real clouds to understand how light plays across their shapes.

Randomize the saturation of the colours to create a sense of varying cloud density. a

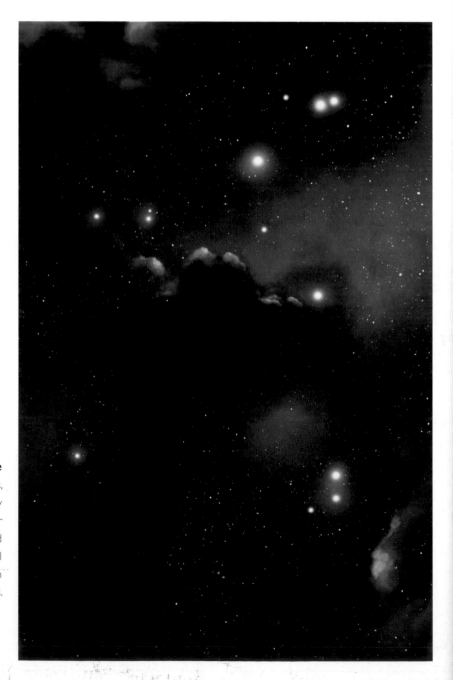

Phase 10: Colours of the nebulae

Continue exploring the shapes and lighting of the nebula clouds, varying the size and shape of the brushes, and take the opportunity to add some variations in colour to the lit areas. The overall colour palette of the piece should remain concentrated in the blue and purple areas of the colour spectrum, so accent and spot colours will work best if they are taken from other areas of the spectrum, such as reds, yellows and greens.

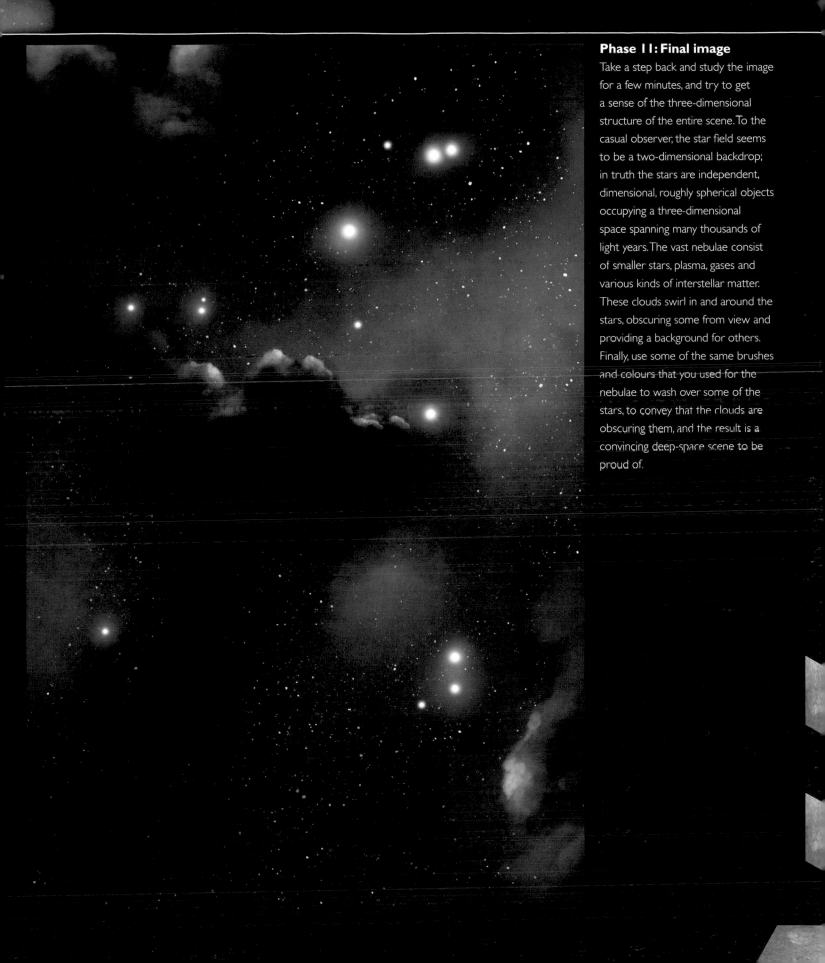

Phase 11: Final image

Take a step back and study the image for a few minutes, and try to get a sense of the three-dimensional structure of the entire scene. To the casual observer, the star field seems to be a two-dimensional backdrop; in truth the stars are independent, dimensional, roughly spherical objects occupying a three-dimensional space spanning many thousands of light years. The vast nebulae consist of smaller stars, plasma, gases and various kinds of interstellar matter. These clouds swirl in and around the stars, obscuring some from view and providing a background for others. Finally, use some of the same brushes and colours that you used for the nebulae to wash over some of the stars, to convey that the clouds are obscuring them, and the result is a convincing deep-space scene to be proud of.

spaceport

Spaceships are a mainstay of science-fiction imagery, but they all need a place to take off from and land. Spaceports are often depicted as giant garages, housing immense vehicles on a scale that dwarfs the human figure. In science-fiction films, spaceports can exist on a planet's surface (such as the Mos Eisley spaceport in *Star Wars*) or in outer space, in orbit around a planet (such as the construction drydock of the USS Enterprise from the first *Star Trek* film). When illustrating large-scale futuristic architecture such as a spaceport, modern airports can provide inspiration in terms of size, lighting and materials, and the need to provide walkways for people to and from large flying vehicles. This demonstration shows you how to create a spaceport on the surface of a planet using a block-in painting technique, whereby the image is created directly on the final canvas (traditional or digital) with no separate line drawing stage.

Phase 1: Initial lines

Select a camera angle that represents the viewer standing at ground level, looking up at an impressively scaled structure. The horizon line will be close to the bottom of the image, with the vanishing points to the far left and right. Lay down a medium-toned, warm grey background colour with a subtle gradient ending in a brighter sky. The main light source in this scene will be general diffuse daylight; like Earth, this planet has one sun so the light will come from a single source overhead. Dust and fog in the atmosphere will scatter the light, reducing sharp-edged shadows. Sketch out the long lines as shown, indicating an overhead roof structure and linear walkway. These initial lines will establish the general perspective of the piece and will serve as a general guide for the painting process.

Phase 2: Main values

Using the lines laid down in the first phase as a guide, block in a dark blue-grey silhouette representing the main structure against the warm sky. Drop in a lighter, warmer grey shape to represent another structure further in the distance. Use cool colours to contrast the foreground structure against the warmth of the sky. Some of the warm grey can be added into the blues to indicate some atmospheric and bounced light from the ground, but overall the colour temperature should still feel cool.

Phase 3: Silhouette refinement

Using hard-edged brushes of varying diameter, start cutting some crisp edges into the main structure, introducing corners and window forms. Using the same brushes, establish some sensors or communications gear at the end of the walkway, remembering to account for the light coming from above and behind the overhanging building

To indicate an urban setting, quickly paint in some tall buildings in the distance. The vertical lines of these buildings converge to a third vanishing point far overhead and to the right. This indicates that the viewer's line of sight is directed somewhere above the horizon line, offering a more dramatic view. The value range for these background buildings should range from medium to light due to the atmospheric perspective (see page 69). Like the foreground structures, they are lit on the front and right sides.

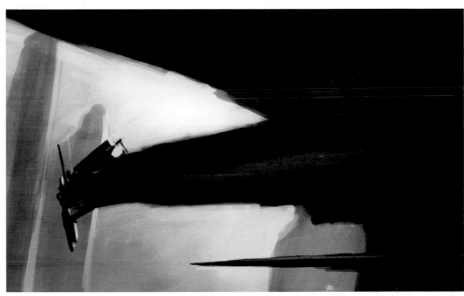

TIP: USING BRUSHWORK TO REINFORCE PERSPECTIVE

In the early stages, make sure that every mark works to help strengthen the perspective effect. This can be achieved simply by orienting your brushstrokes to align with the vanishing points. For example, in the roof structure, the majority of the brushwork is aligned with the left-hand vanishing point and even though much of this will be covered in the final rendering, the underlying texture will still be subtly apparent. Similarly, the brushstrokes on the suspended walkway are also oriented with the perspective. Subsequent layers of texture and brushwork then all work together to help emphasize the three-dimensional quality of the architecture.

Phase 4: Structural additions

Begin adding more indications of scale and structure in the main building, such as openings in the roof and windows in the walkway. Regular, repeated elements like these are very useful for conveying perspective. Just make sure that the placement of these details conforms to the horizon line and vanishing points established in the original sketch. Use a lighter cool-grey colour for the new structural details. Using the warm, pale-yellow light from the sky, brighten the structural elements where they are being hit with light through the openings in the roof.

Phase 5: Initial details

Continue adding repeated elements and texture to indicate mechanical and structural systems in the roof and along the side of the walkway. Adding some extra bracing and communications gear along the edges of the walkway and landing platform can add visual interest to the silhouette. Elements such as stairs can start to convey a specific sense of scale. Refine the look of the roof structure by adding some of the same kinds of grid shapes, which also help reinforce the perspective. These grids cover the skylight openings from the previous phase, but a hint of daylight can still be seen coming through the gaps in the bracing.

The details don't need to be overly specific; it's better to indicate and imply detail at this stage.

Phase 6: Artificial lighting

Start adding some spots of bright blue and green to indicate sources of artificial light. Choosing colours with contrasting colour temperatures and increased saturation (cool blues and greens Vs the warm pale yellows of the sky) emphasizes the artificial quality of the lights. Pump up the contrast by adding more of the warm light, silhouetting the shapes of the roof and extended walkway. By layering more details and shapes in front of the lights, you can start implying some interior spaces and internal structures. Be sure that the details being added are still conforming to the perspective lines set up earlier.

Layer complex, manufactured-looking shapes over randomly scattered, brightly lit areas to imply interior structural details. Use mottled blue and white lights behind the grid panels to give the impression of complex interior spaces.

Phase 7: Atmosphere

In the large windows at the top, add some linear shapes (representing interior lighting panels) in bright light-blue with a hard-edged brush, following the perspective of the roof plane. Using an airbrush, add some darker blue glows to accentuate the lighting, and to create a subtle atmospheric perspective effect (see page 69). In the areas lit by daylight, add some light bloom effects by bringing some of the warm colour across the walkway and in and around the edges of the roof. Use splotches and puffy brushstrokes to create a sense of humidity or smog particles in the air. To add scale, paint in some smaller ships on the left-hand side (if working digitally, these could be modelled in a 3D program first – see page 15). To increase the sense of depth, vary the size of the ships so that some appear closer to the viewer than others.

Phase 8: Lighting design

Additional lighting in the ceiling plane, along with some shafts coming from the individual light sources help convey the idea of a large, cavernous space. More light blooms and atmosphere from the artificial lighting increase the sense of complexity and activity in the main part of the space. Paint in a medium-sized transport ship on the surface of the landing platform. Increase the lightness of the platform's surface, so that the cast shadow from the ship creates more contrast. Using a fairly small-diameter brush, indicate some tiny spotlights on the ship, which light up some of the ship's lower surfaces as well as the platform beneath it.

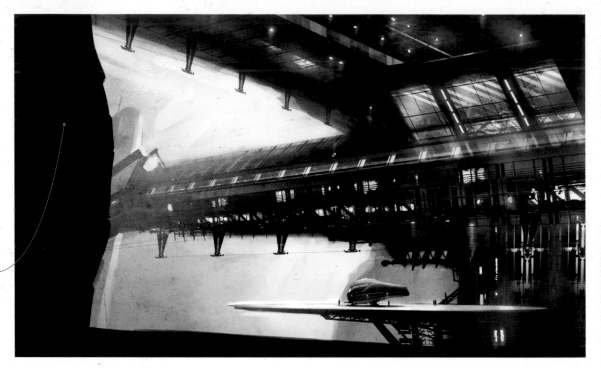

Phase 9: Layering space

Up to now the image is working fairly well, but might be improved with the addition of a foreground structural element. This has two functions; to provide some areas of close-up details and also to enhance the feeling of depth in the scene. Add a darker foreground shape, somewhat organic in nature but also having parts that are more orthogonal and follow the perspective of the scene.

Begin with a silhouette and gradually carve out some edge details. To provide a bit more room for the foreground element and to straighten out the landing platform, rotate the scene very slightly in a clockwise direction. If working digitally this is easily done using the Rotate Canvas and Crop tools. If working traditionally, manually rotate the paper and use a mask to hide the areas no longer in the frame.

Phase 10: Foreground refinement

Add detail to the edges of the foreground silhouette using some of the same shape vocabulary as in the other structures in the scene. The specific shapes added here are handrails, radio antennae and other communications or utilities devices, and their main purpose is to help tie the foreground and background architecture together visually, making it feel unified. As always, make sure you follow the perspective lines from the original line sketch. To push the middle ground back a touch, use a large, soft-edged brush to add a light wash of medium blue to give the effect of atmospheric perspective (see page 69) on the right side of the image, which increases the contrast between the middle ground and the railings in the foreground.

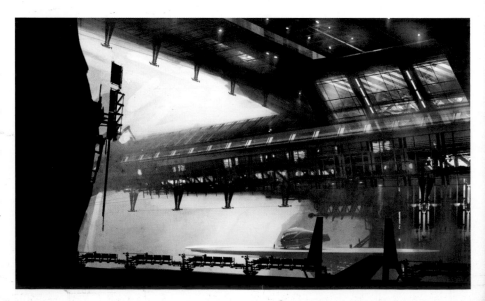

Phase 11: Final image

Finish rendering the foreground architecture by adding colour and lighting. The details should not overwhelm the main structure and landing platform, which should remain the focal point. There should be just enough specific detail to tell the viewer something about the materials and construction of the spaceport, which consist primarily of structural steel (or its futuristic equivalent) and high-strength glass. Use shapes similar to the overhead grids from the earlier phases to delineate the foreground walkway, adding a vivid-yellow warning stripe to mark its edge. A warm-yellow light source on the foreground walkway also helps to separate this area from the background architecture, which is primarily rendered in cool colours. Place some human figures throughout the scene to lend the appropriate sense of scale, and help convey the image of a large, technologically advanced facility dedicated to the arrival and departure of all kinds of space-faring vessels.

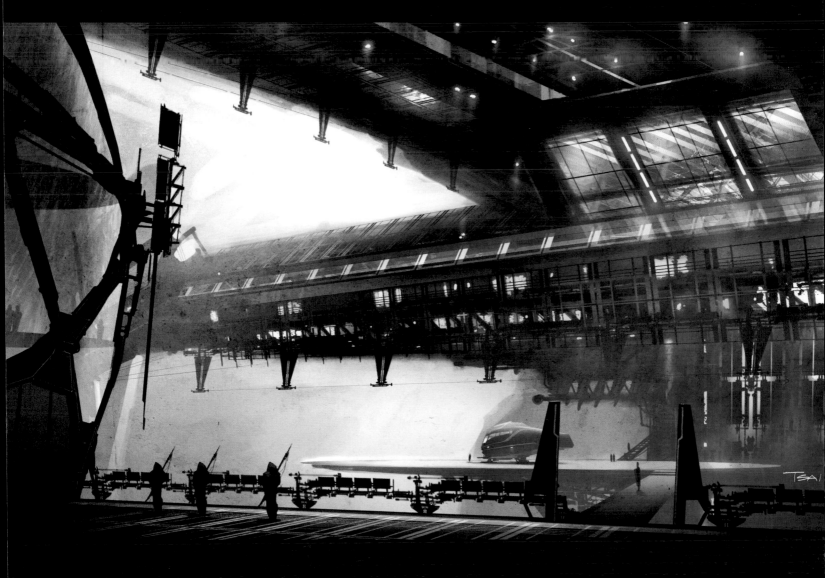

high-tech interior

At some point in a science-fiction narrative, a scene will take place within a building or artificial structure. Although the particulars of the design, materials, lighting or function may vary wildly depending on the nature of the story, the basic rules of colour, lighting and perspective governing the illustration of a futuristic interior remain the same as the ones you would use to depict a modern-day space. The location shown in this demonstration is a medical research facility situated in a large city several years from now. The furnishings and equipment are updated versions of those you might find in a hospital today, including some you might not. A setting like this might be necessary in a science-fiction story in the event that a character gets injured in an intergalactic battle, or becomes infected with an alien virus. The demonstration builds on a basic interior three-point perspective set-up.

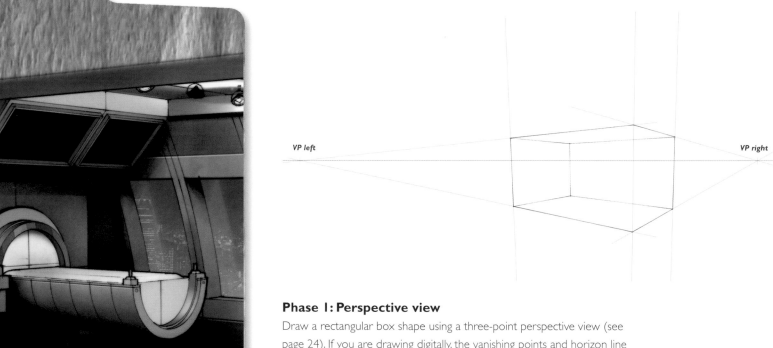

VP left

VP right

Phase 1: Perspective view

Draw a rectangular box shape using a three-point perspective view (see page 24). If you are drawing digitally, the vanishing points and horizon line can be placed on a different layer, so that they can be easily removed. If you're working on paper, another sheet of paper containing the horizon line and vanishing points can be laid under the current sheet. For the third vanishing point far below the horizon, it may be necessary to estimate its exact location. For the remainder of the phases, the horizon line and vanishing points will not be shown, so the drawing remains clear.

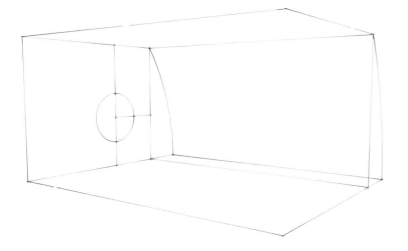

Phase 2: Construction lines

Using the vanishing points established in the previous phase, create some guidelines as a basis for the interior design of the space. The arcs along the right side of the room will form the basis for a curved wall of windows, and the circle on the back wall indicates where a retractable hospital bed will extend from the wall. Use an ellipse template to draw the circle in perspective (see Tip, page 73) making sure the minor (shorter) axis of the ellipse converges on the vanishing point to the right, and the major (taller) axis goes towards the third vanishing point, far below the bottom edge of the page. The arcs forming the wall of windows are technically also portions of very large ellipses, but can be approximated using French curves.

Phase 3: Major room components

Extend the bottom half of the hospital bed a short distance into the room. This is the bottom half of another ellipse, with the minor axis forming the top of this shape. The degree of the ellipses delineating the ends of the bed needs to be fairly broad, 45 or 50 degrees, but this may depend on how extensive your collection of ellipse templates is. Using the two end arcs as guides, subdivide the wall of windows into five more or less equal segments. The curvature of these arced segments will appear to straighten out as they go from left to right on the page. The reason for this is that the planes containing the arcs also converge on the right-hand vanishing point; we are seeing these arcs at ever-increasingly sharp angles (almost edge-on for the last one), so the curvature is less apparent.

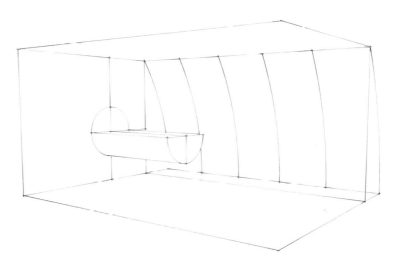

Phase 4: Room equipment

Begin indicating a secondary level of detail on the equipment wall of the room, adding a flange on the wall behind the retractable bed and setting up the frame for an overhead air-handling unit. The lines marking out the box shape of the overhead equipment converge on the right-hand vanishing point, and the vertical lines converge on the third vanishing point far below. The focus of the room is on the bed and associated diagnostic and maintenance equipment, so adding levels of detail here will help draw the viewer's eye (see Tip, page 101).

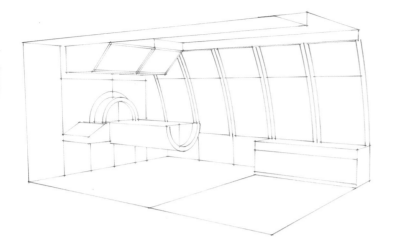

Phase 5: Equipment refinement

Start adding some new geometry to depict equipment such as a wall-mounted computer monitor and the overhead air-handling unit. To help reinforce the central axis of the room, carve out a negative space in the ceiling, making an area for some specialized overhead lighting later. Introducing this overhead cavity in the ceiling helps create a visual axis in the room, which follows the direction of the suspended bed, and which is also punctuated graphically with the circular geometry on the wall at the head of the bed. Draw the individual window mullions and storage cabinet, making sure that the lines converge on the relevant vanishing points. The upper and lower horizontal lines along the length of the wall of windows indicate where the wall will be 'pushed out' slightly to create a windowsill several inches deep.

Phase 6: Final line details

Add the final layer of detail, building on the careful line work and perspective set up so far. Using the subdivisions of the window wall drawn in the previous phase, introduce dimension to the windows by adding some thickness to the frames. Indicate some cabinet doors by dividing the front of the cabinet into regular vertical and horizontal sections. Build up the detail on the overhead air-handling unit, indicating panel lines and joints. Subdivide the shapes on the computer terminal, creating smaller sub-panels. Add more panel lines to the wall behind the bed, introducing some arbitrary angled shapes. Draw in another set of lines on the floor and walls to guide the placement of different material types in the later rendering stages.

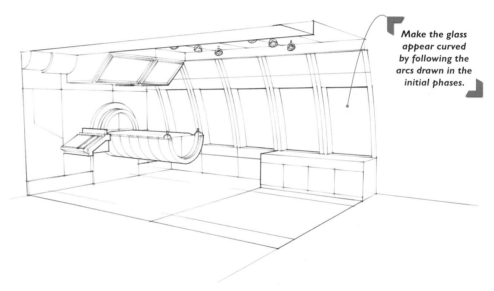

Make the glass appear curved by following the arcs drawn in the initial phases.

Phase 7: Basic colour block-in

If you are working digitally, scan the image and use the Levels tool to create a clean line drawing (see page 16). If working traditionally, transfer your line drawing to the final media using a light box. Lay in some neutral base colours to establish the basic colour scheme in the room. As a visual short-cut, the portion of the page outside the room's volume is shaded a dark grey – this is not actually something the viewer would see in reality. Use a darker warm grey on the equipment wall at the back of the room to indicate areas of different materials and colours. The colour/material contrast also helps draw the eye, reinforcing this area as the focal point of the piece.

TIP: LEADING THE EYE

Areas of high detail and contrast in an image naturally attract the viewer's attention. You can therefore subtly lead the eye to the focal point by concentrating details in that area and reducing details in the less important places. Draw lots of seams, edges and joints between the different materials in the areas where you want to draw the viewer's eye (such as the junction between the wall and bed, and also the computer terminal). Then gloss over these details in parts away from the focal point (such as the low cabinets on the right-hand side of the room).

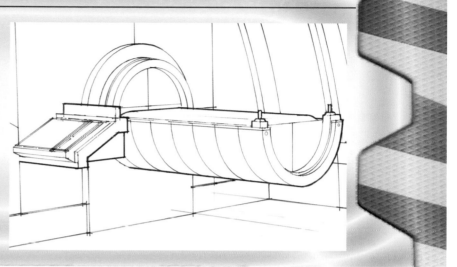

Phase 8: Initial material indications

Use a cool, bright grey on the floor to begin indicating a polished, reflective surface, perhaps some high-tech, stain-resistant material. Apply a cool greenish-grey gradient on the windows to emphasize their curved geometry, and add darker and lighter greys for important surfaces such as the storage cabinets and overhead lighting panel. Finally, use a bright blue to indicate a source of illumination from the computer control panel.

Give the floor its own distinctive colour to enhance the sense of space. Create a clear visual transition between the floor and the walls to help the viewer understand the layout of the room.

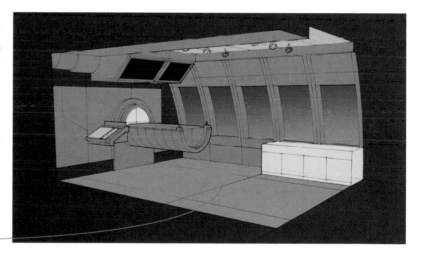

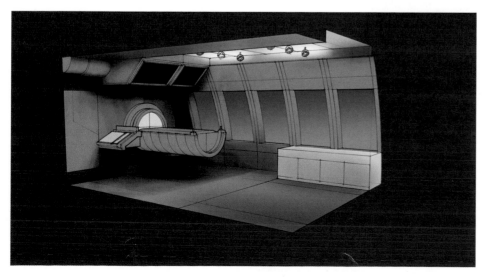

Phase 9: Shadows

Using a cool, dark grey begin roughing in the cast shadows from the overhead lighting, with a combination of an airbrush and soft-edged round brushes. Because there are multiple light sources in the room, cast shadow edges will be more diffuse than if there were a single light source, and may appear to have multiple edges. This effect can be indicated by introducing some very subtle edges within the shadows, bringing in a degree of randomness. Use an airbrush to soften the outer edges of the cast shadows, creating a feeling of diffuse lighting in the room.

Phase 10: Indications of volume

Add some smooth gradients of cool blue-greens and greys to the frame and lower surface of the bed to indicate its machined and slightly reflective surface. Some bounced light from the wall opposite the windows (not shown in the image) casts a diffuse shadow of the control panel on to the side of the curved bed shell; paint these shadows using a soft-edged brush and a cool, dark grey colour. Begin rendering the curved surface of the flanges at the head of the bed as well.

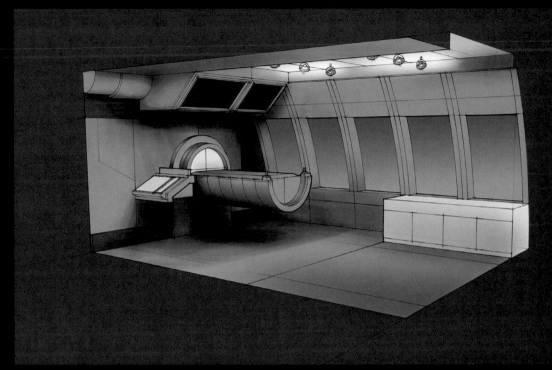

Avoid areas of flat colour across a long expanse of wall, as it can flatten the image. Vary the value of the colour, reacting to light sources and cast shadows. An extremely subtle gradient from light to dark, or light-dark-light, along longer sections will add to the sense of realism.

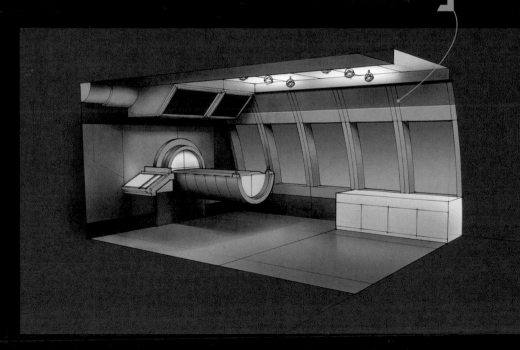

Phase 11: Materials

Using a large, soft-edged brush, apply a red-orange colour to portions of the wall, indicating some changes in materials in different areas of the room. The orange parts of the wall have a more matt, fabric-like finish, and so will not exhibit reflections like some of the more metallic surfaces in the room. On the back wall, the grey metal panel reflects some of the blue light being emitted from the computer. Indicate this by adding a subtle hint of blue-green to the wall, just enough to bring some of that colour to the wall. A hard-edged, dark shape on the wall, under the cantilevered bed, indicates a cast shadow effect from the edge of the computer terminal.

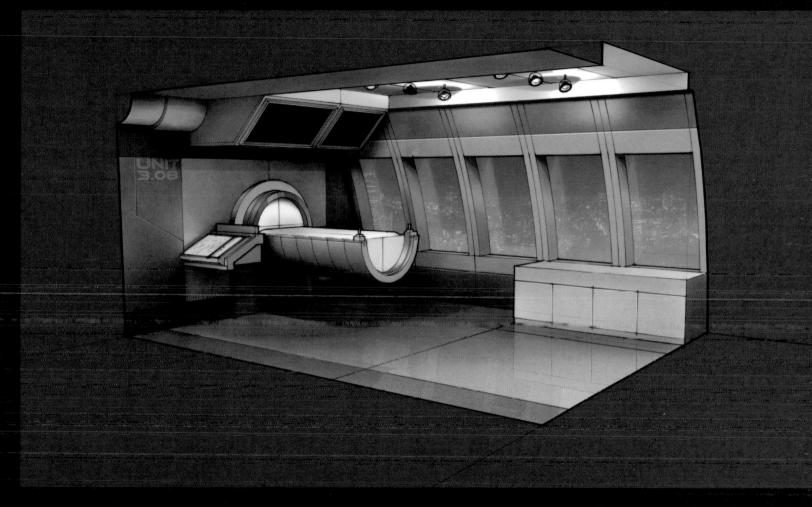

Phase 12: Final image

Sharpen up some of the shadow edges using a hard-edged brush, leaving some diffuse edges to indicate the multiple light sources. Finish applying the orange material on the walls, and indicate some glow by brushing in a lighter yellow-orange near the ceiling and along the back wall. Use a hard-edged brush to paint a reflection of the computer screen on the metallic part of the wall. The glow from the screen affects the whole wall, but the more precise reflection can be seen only on the metal section. Some of the light from the screen can also cast a faint blue glow on the metallic material of the ceiling. Indicate a subtle reflection in the floor by carrying some of the lines and shapes down towards the third vanishing point below. Using a small brush and a light orange colour similar to the base wall, paint in a text graphic on the wall. Finally, add a suggestion of a futuristic cityscape outside the windows by faintly painting in geometric shapes representing buildings.

SPACE OPERA

concept, cast and plot

The space-opera concept is best characterized by its epic scale, encompassing numerous locations throughout space. Space opera tends towards the romantic or melodramatic, with roots in the pulp magazines of the 1930s and 40s. It has more in common with adventure stories of that period than the more technology-oriented 'hard sci-fi' stories that emphasized the science aspect of science fiction, and could therefore almost be considered 'fantasy'.

Space opera focuses mainly on the characters and the interactions between them, and is typified by a very clear divide between good and evil. The cast adheres to certain archetypes: the hero – handsome, intelligent and athletic; the villain or antagonist, who usually does not have quite the physical abilities of the hero but who makes up for it in cunning; and the beautiful damsel in distress. The space-opera story that forms the basis for the following design exercises and movie poster illustration borrows heavily from early film serials such as *Buck Rogers* and *Flash Gordon*.

The 'good guys' in the story are members of the Planetary Federation, an organized collection of a number of different star systems and their associated planets. The narrative takes place at a time where the human race has had the opportunity to develop the faster-than-light spacecraft technology needed to spread throughout the galaxy. The Planetary Federation consists mainly of these human-developed planets.

The Galactic Imperium, a galaxy-wide empire ruled by a mysterious High Council, comprises the 'bad guys'. The Galactic Imperium encompasses many more worlds than the Planetary Federation does, and is centuries older. The High Council is shrouded in secrecy but it is rumoured that the members come from different alien races.

Our heroes are a group of three citizens of the Planetary Federation. Todd Almeida, Nathan Masato and Cygnus Lake are sent on a mission to assist Dr Vitaly Fentonov, a robotics and artificial intelligence specialist, and Ingrid, his experimental android, in their defection from the Galactic Imperium. Uvei Mortis, an overlord of the Galactic Imperium, intends to subvert Fentonov's robotics technology to create an army of intelligent and amoral warrior robots, not knowing of Fentonov's intention to leave the Imperium and ally with the Planetary Federation ...

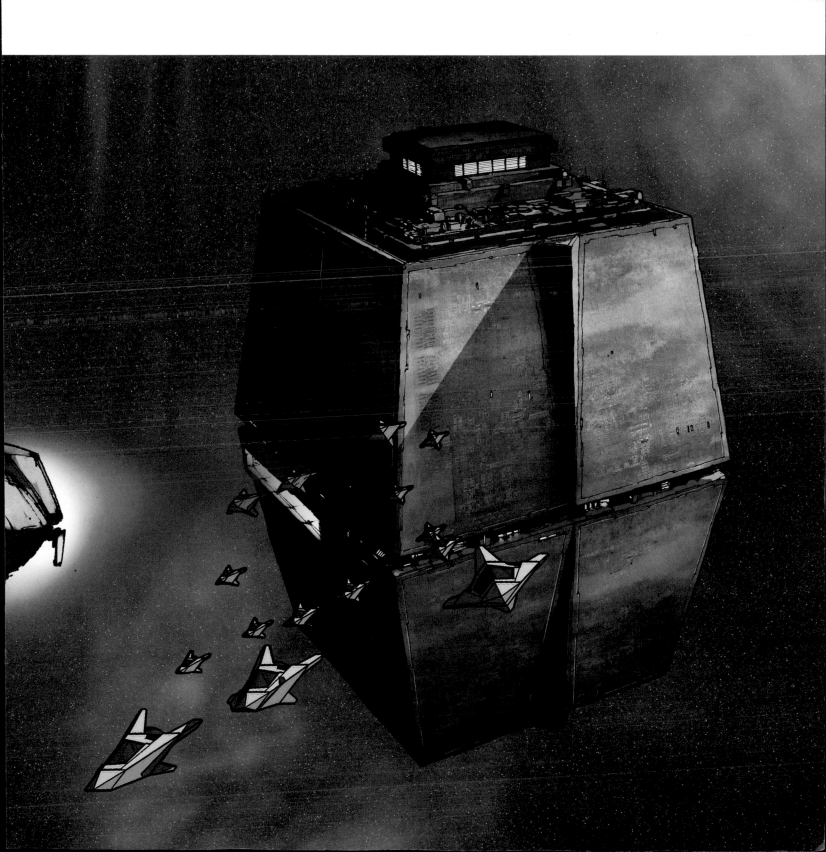

designing the heroes

The archetypal hero of the space opera is typically an all-in-one package of physical ability and good looks, with very few flaws. This is the sort of character that 'all men want to be and all women want to be with', which is typical of a space-opera story from the early 20th century. A hero with no flaws is certainly heroic, but tends to be not quite as interesting as some of the supporting characters with less-than-perfect character traits. In order to add a new spin to the genre, the protagonist in our space opera has been morphed into three different characters, each embodying different aspects of a science-fiction hero.

TODD ALMEIDA

Almeida is a brash, street-smart hothead. He is very pro-human and is deeply suspicious of robotics technology. He is a long-standing member of the Planetary Federation, having formerly been employed by the Federation's Defence Force. Almeida currently remains in good standing with the Force, but just barely. He is now retired from active service and is a freelancer, who often takes side jobs from his former employers.

NATHAN MASATO

Masato and Almeida are best friends and have worked together for many years. Masato is a little older than Almeida, and is more reserved and open minded about robotics and artificial intelligence. Masato's tendency towards caution and conservatism balances Almeida's impulsiveness and rash behaviour. They make a good team, complementing each other's strengths and weaknesses in their missions together.

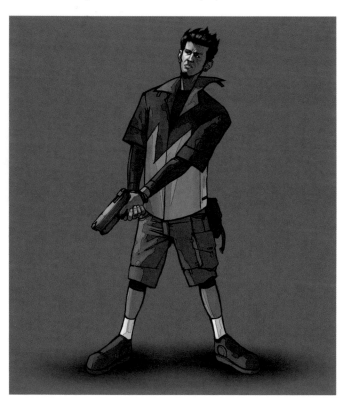

TODD ALMEIDA
This concept sketch explores some costume ideas that diverge from the clothing style normally associated with the space-opera hero.

NATHAN MASATO
A concept sketch of Masato, showing how he might dress when not in his Planetary Federation uniform.

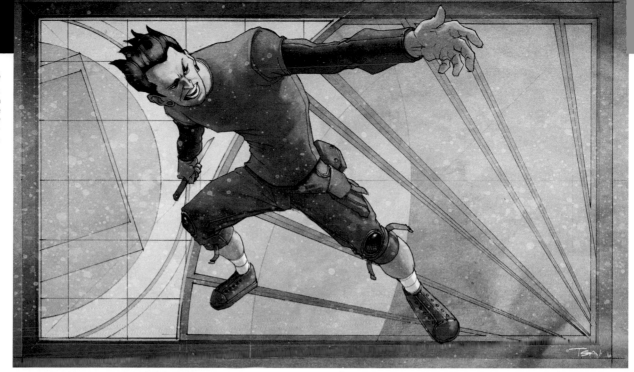

YOUNG TODD

A younger Almeida, again exhibiting a costume design one would not normally expect of an intergalactic hero.

ACTION SHOT

This in-progress illustration depicts Masato in action during a firefight aboard an enemy space station.

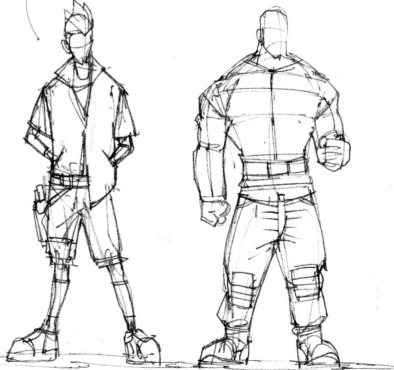

In these drawings, there are no facial features but the characters' personalities are still readily apparent.

CHARACTER SKETCHES

These early sketches of Almeida and Masato show the importance of silhouette over detail. The physical build of each character, as well as the style of their clothing, help give them both easily readable visual identities.

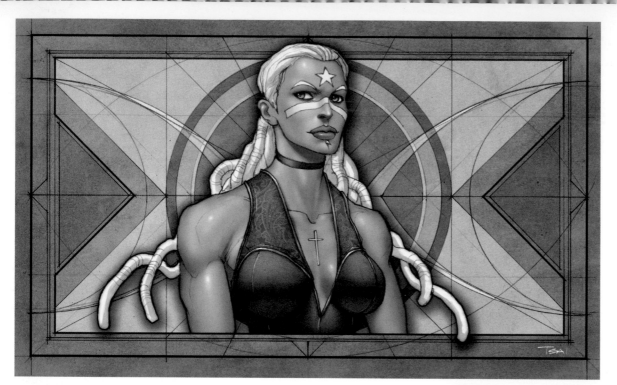

CYGNUS LAKE

This conceptual drawing portrays a time earlier in Lake's freelancer career, before the accident that led to her arms being replaced with powerful cybernetic prosthetics.

YOUNG CYGNUS

Lake is shown here fresh out of flight training school at the Planetary Federation Academy, well before beginning her present career as a cyborg freelance pilot and operative for the Federation.

CYGNUS LAKE

Lake is a cyborg and works as a freelance pilot for the Federation. She is a highly skilled and experienced flier, and benefits from her various cybernetic enhancements (see pages 46–51). She is also a very by-the-book operative, and often butts heads with Almeida's impulsive nature.

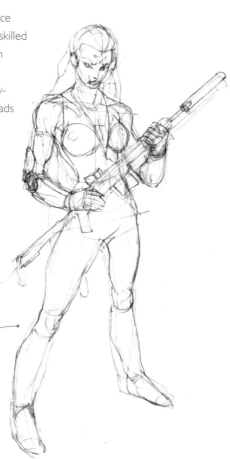

EARLY SKETCH

Cygnus Lake's form-fitting clothes give her a fairly straightforward silhouette; visual identifiers come in the form of her long white dreadlocks and the graphic colour shapes of her artificial arms and monochrome outfit.

Lake's personality comes through in how she carries herself; rather than a standard fashion model or damsel-in-distress pose, her stance shows her alertness and physical ability.

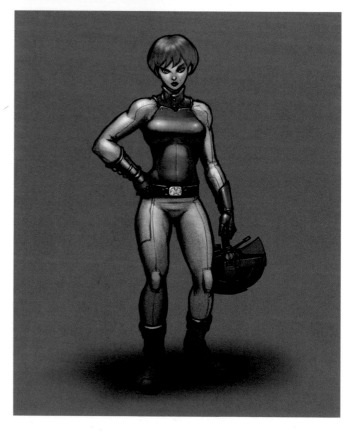

EARLY CHARACTER DESIGN

Some of the sketches shown on these pages depict early versions of the characters, when they were based more on their function in the story rather than for the purposes of portraying specific personalities. For example, space opera almost always has characters who make their living piloting spaceships, whether for themselves or as part of a fleet or government.

Early character ideas for the space-opera project began primarily as exercises in designing uniforms for potential pilots or military personnel. These explorations would later inspire parts of the backstory of some of the characters, who at some point in their lives served in the military of either the Galactic Imperium or the Planetary Federation, or at least had some significant contact with these institutions.

Visual exploration of different points in the past life of your characters can help solidify them in your mind, forming a more solid and coherent tapestry. It can help you determine how and why certain characters act in and respond to certain situations, and give clues as to how they look and carry themselves later in the story.

TYPICAL HERO
Early character studies for some of the space-opera characters yielded this fellow, who is representative of the more typical heroic space-opera protagonists of the early to mid-20th century. The hero's costume has slightly militaristic overtones.

COSTUME IDEAS
Another early concept sketch shows a hero character wearing an environment suit; the addition of a helmet allows him to venture into space.

designing the villains
and supporting characters

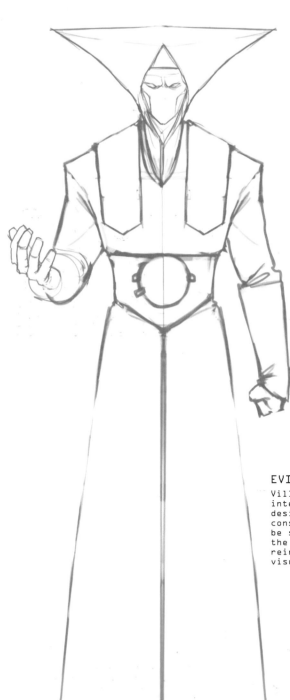

The space-opera villain presents the hero with a seemingly unconquerable foe. In some instances the villain might have physical abilities equal or better than those of the hero, but typically the power of the villain comes from his (or her) greater intellectual abilities, or metaphysical or supernatural powers. Because the villain is not bound by the audience's expectations of heroism, this character has the potential to be a bit more multi-faceted in terms of motivation, personality and appearance.

Alongside the hero and the villain are various secondary characters that can be used to fill various storytelling needs. They can vary from the nameless masses, such as the soldiers in an evil warlord's army, to quirky individuals such as the mad scientist who creates a vital piece of technology.

UVEI MORTIS
Mortis is the main antagonist in the story, and serves the same role as Darth Vader, Ming the Merciless, or any other person who stands in the way of the heroes accomplishing their mission. He is an ambitious overlord in the Galactic Imperium, and controls the systems neighbouring the Planetary Federation.

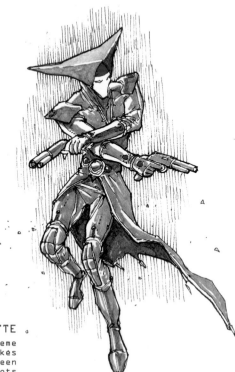

EVIL OVERLORD
Villains often are the most interesting characters to design; being freed of the constraints of having to be sympathetic or heroic, the illustrator has free rein to create a striking visual identity.

COLOUR PALETTE
The black-and-white colour scheme of Uvei Mortis' costume evokes the archetypal battle between good Vs evil. The key spots of red also provide a subtle reference to blood and danger.

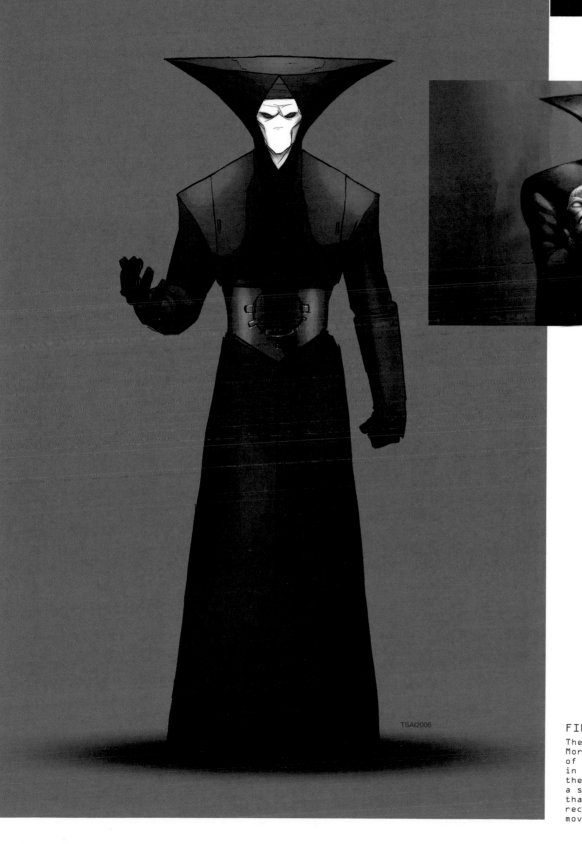

TSAI2006

DEATH MASK
The blank white graphic
nature of his facemask
mimics the appearance of a
human skull, communicating a
strong message of death and
destruction to the viewer.

FINAL DESIGN
The character design for Uvei
Mortis is the most abstract
of the cast of characters
in this story, providing
the opportunity to create
a strong, unique silhouette
that will be instantly
recognizable in the final
movie poster illustration.

DR VITALY FENTONOV

Fentonov is a brilliant scientist who has developed the technology to create robots with artificial intelligence, allowing them to become fully aware, sentient beings. He works for the Galactic Imperium by virtue of being a native citizen of a planet in the Greater Imperium Dominion, but otherwise has no specific political allegiance. He is almost a savant, possessing a genius-level intellect in the area of robotics and artificial intelligence, but very little in the way of awareness of the greater world around him.

PRINCESS TRISTAN MORTIS

Tristan is the amoral offspring of Uvei Mortis. She has inherited her father's unbridled ambition and lust for power, but little of his self discipline. Tristan's persona is based on characters such as Princess Aura, the daughter of Ming the Merciless in the *Flash Gordon* comic strip and films, and Ardala, a similar character in the *Buck Rogers* universe.

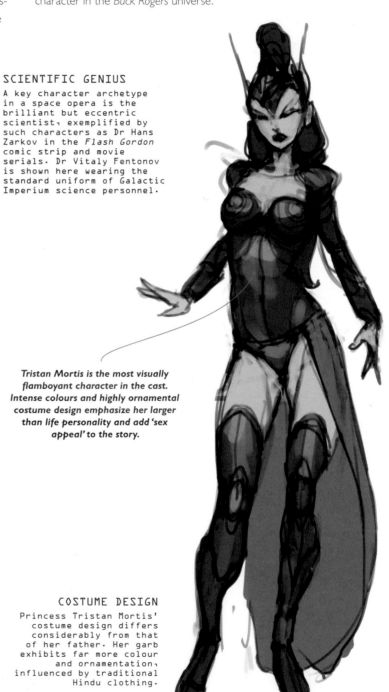

SCIENTIFIC GENIUS

A key character archetype in a space opera is the brilliant but eccentric scientist, exemplified by such characters as Dr Hans Zarkov in the *Flash Gordon* comic strip and movie serials. Dr Vitaly Fentonov is shown here wearing the standard uniform of Galactic Imperium science personnel.

Tristan Mortis is the most visually flamboyant character in the cast. Intense colours and highly ornamental costume design emphasize her larger than life personality and add 'sex appeal' to the story.

COSTUME DESIGN

Princess Tristan Mortis' costume design differs considerably from that of her father. Her garb exhibits far more colour and ornamentation, influenced by traditional Hindu clothing.

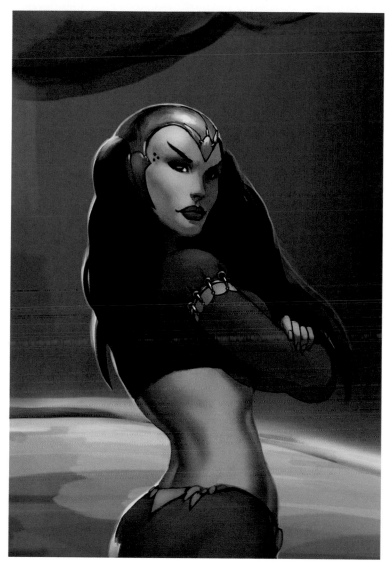

IMPERIUM GUARDS

The Imperium Guards consist of ranks of human and humanoid conscripts from various worlds in the Galactic Imperium. Unknown to them, Uvei Mortis' plans to supplement and then gradually replace the less reliable conscripts will require a cruel perversion of Dr Fentonov's technology.

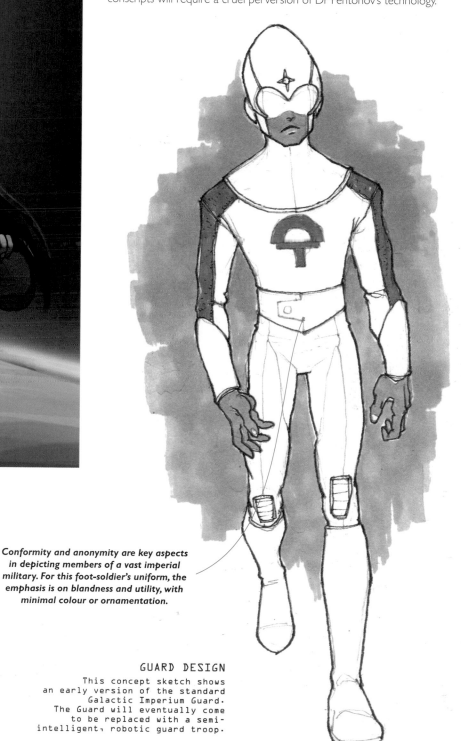

HUMAN FEATURES

Whereas Uvei Mortis shows us only a white mask with little ability for facial expression, his daughter is clearly human, or at least humanoid, and can exhibit a wide variety of moods. She has inherited her father's temperament though and is rarely seen with a smile, except one of smug satisfaction if things go according to her plan.

Conformity and anonymity are key aspects in depicting members of a vast imperial military. For this foot-soldier's uniform, the emphasis is on blandness and utility, with minimal colour or ornamentation.

GUARD DESIGN

This concept sketch shows an early version of the standard Galactic Imperium Guard. The Guard will eventually come to be replaced with a semi-intelligent, robotic guard troop.

designing the robots

Robots are one of the defining characteristics of a science-fiction story. As mobile, sometimes autonomous machines, they occupy a broad niche that exists between inanimate objects and sentient human (or alien) beings. Robots play a central role in the storyline of this space opera. The technology being developed by Dr Vitaly Fentonov will potentially give robots self-awareness, allowing them to function as fully autonomous, intelligent beings. Uvei Mortis wants to take Fentonov's research in a different direction, creating a huge slave race of warrior robots.

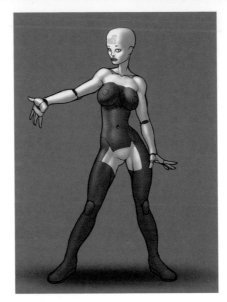

HUMANOID ROBOT

A robot with a silhouette and facial structure inspired by human anatomy more readily allows the viewer to form an emotional attachment. Adding an indication of construction, in the form of visible joints, shows that the robot is made from synthetic materials, communicating the idea of an artificial being.

INGRID

Ingrid represents the pinnacle of Dr Fentonov's research. She is state of the art — the first truly self-aware, learning robot … or at least the first to survive long-term.

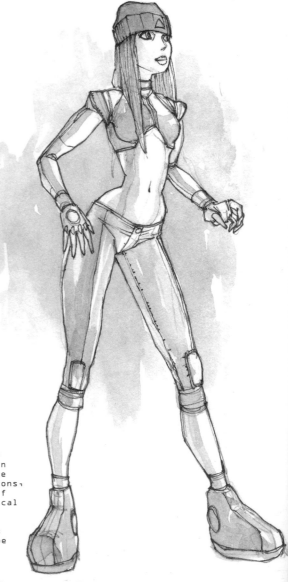

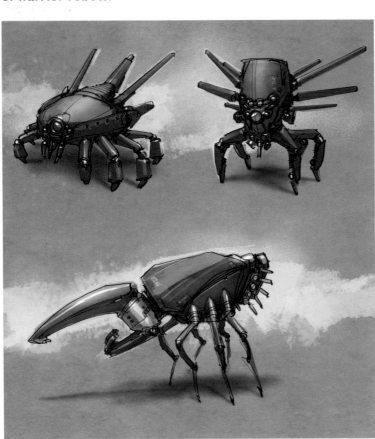

ROBOT CONCEPT SKETCHES

Insects can provide great inspiration for robot designs. Because they wear their structure on the outside in the form of exoskeletons, their appearance feels very mechanical and constructed, which is similar to the way robots might typically be put together.

DESIGN CONCEPT

This concept illustration shows Ingrid's final design as a human-like but clearly artificial construction, exhibiting characteristics that place her somewhere between human and mechanoid.

IMPERIUM TROOPER

The prototype Imperium Troopers are the result of Uvei Mortis' twisted perversion of Dr Fentonov's research. They are not quite self-aware and intelligent in the way that Ingrid is. There are rumours that the Trooper technology incorporates a biological component gruesomely harvested from unwilling Galactic Imperium conscripts.

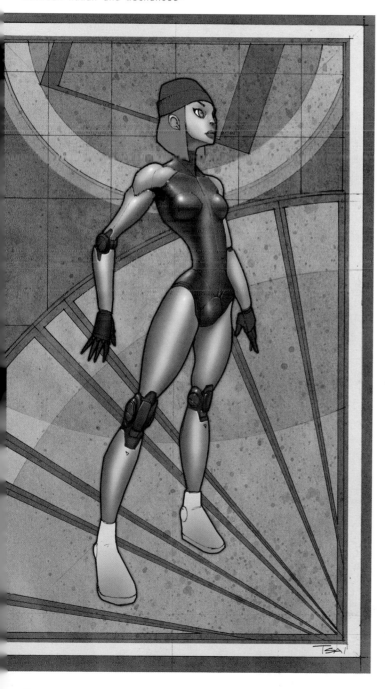

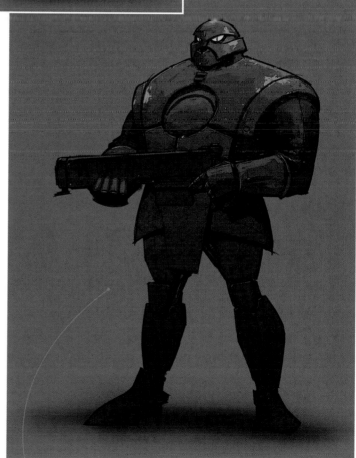

Designing robots that mimic the human form can present opportunities to exaggerate proportions, or to stylize anatomical features into abstract graphic shapes.

designing the vehicles: planetary federation

The vehicles used by the Federation Defence Force include older, second-hand models, and a large number of out-of-production vessels. In comparison to the Galactic Imperium, the Planetary Federation devotes a far smaller percentage of its resources to war ships, and so relies on maintaining and repairing older vessels. Federation Defence ships therefore exhibit more wear and tear than Imperium vessels, and often are marked with graffiti. Some pilots and owners regard the decoration on their ships' exteriors as a matter of pride.

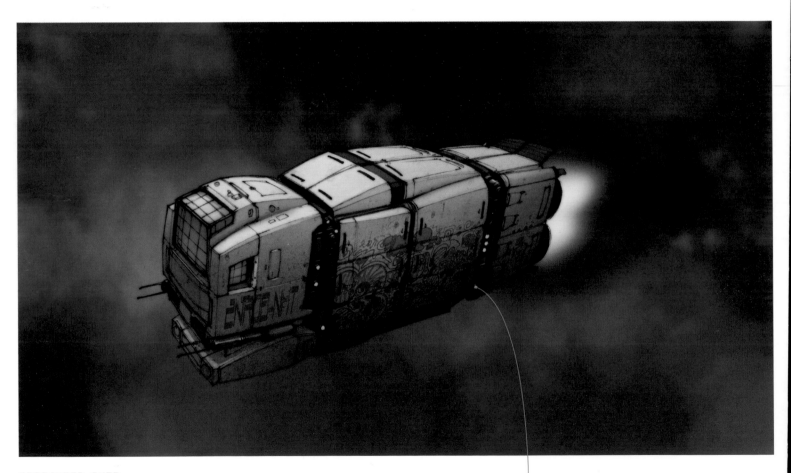

FREIGHTER SHIP

'Marian's Path of Righteousness' is an old freighter ship that belongs to Cygnus Lake. It is almost 30 years old, and its scars and graffiti show it. Although the main chassis of the ship is practically an antique, Lake periodically upgrades its engines and sensors. The ship is based on a modular system that allows the owner to add or remove cargo sections as required. 'Marian's Path' has had some of its cargo sections modified to contain military-grade weapons, allowing its pilot to take on combat missions for the Federation on a contract basis.

Combine influences from different, unlikely sources to create an interesting spin. The design of Cygnus Lake's freighter ship was inspired by New York City subway cars covered in artistic graffiti.

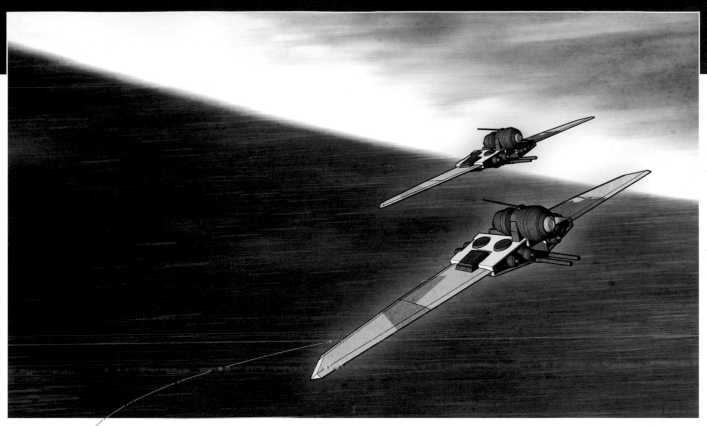

FROM SKETCH TO FINISH

This image was created using a combination of the 3D modelling program Google SketchUp and the 2D digital painting program Photoshop, based on the geometric studies shown in the early sketch (left).

A good strategy for creating visually striking and memorable spaceship designs is to use simple, recognizable geometric forms as a base (see pages 18–19).

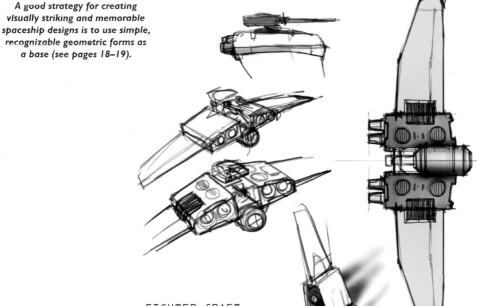

FIGHTER CRAFT

The standard single-person fighter craft used by the Federation Defence Force is reminiscent of the fighter planes of Earth's World War II era in its shapes and details. These are older style, short-range spacecraft built at the Mars Federation Shipyards 10 to 15 years ago. They were chosen by the Planetary Federation for their relatively simple construction and maintenance. They are not the state of the art, but they are dependable.

designing the vehicles:
galactic imperium

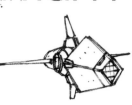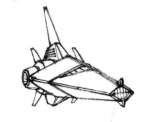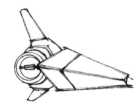

In the same way that the main villain presents the hero with an intimidating foe, the spaceships of the enemy appear to be technologically superior to those of the protagonists, presenting unlikely odds for success in an armed encounter. The Galactic Imperium benefits from a large defence budget funded by heavy taxation of the many systems of the Imperium. Galactic Imperium ships are characterized by their utilitarian geometric forms and clean lines.

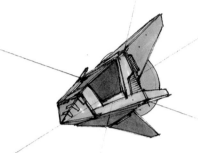

The strategy of beginning with simple geometric primitives is employed again here in the hardware design. Quick sketches allow you to explore different configurations of shapes to determine a silhouette that will be interesting and recognizable from several different angles.

DESIGN SKETCHES

The Imperium ships are typically the product of large-scale nano-assemblers that create spacecraft and other hardware molecule by molecule, according to extremely detailed specifications drawn up by Imperium engineers. It is rare for an Imperium ship to undergo more than one long-term mission, as it is often obsolete by the time it returns to its drydock.

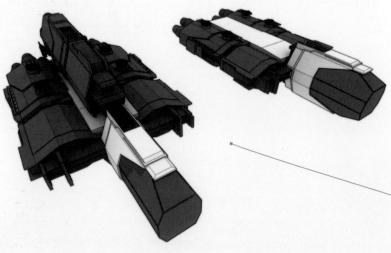

Using a 3D modelling program such as Google SketchUp can be a good way of exploring variations in the arrangement of simple geometric forms. This image shows a couple of variations using a simple kit of modular parts.

BATTLESHIP

This concept sketch was based on the
geometry studies shown opposite. Imperium
battleships are built on a modular system
that allows engineers to specify different
propulsion configurations depending on
mission requirements. Weapons systems, sensor
suites and shielding are also modular and are
installed on a mission-by-mission basis.

STRIKE FIGHTERS

Like the larger ships in the Imperium fleet, the
single person strike fighters are built using
nano-assemblers according to constantly updated
design specifications. They are notable for their
alien-looking geometric forms, which contrast
sharply with the more worn, hand-built ships of
the Planetary Federation.

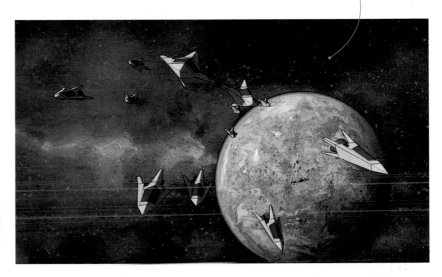

*This illustration was assembled using 3D geometry created in Google
SketchUp and a backdrop painted in Photoshop. The ships are simple
geometric forms based on the thumbnail sketches shown opposite.*

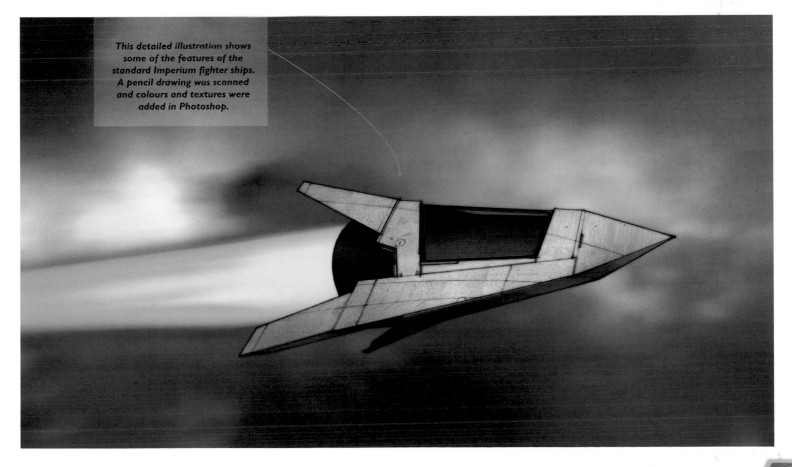

*This detailed illustration shows
some of the features of the
standard Imperium fighter ships.
A pencil drawing was scanned
and colours and textures were
added in Photoshop.*

designing the architecture

The architecture and environments that form the different locations for this space opera provide numerous design opportunities to explore the level of technology, mood, scale and influence of other cultures – human and alien. The scale of architectural elements often overlaps with the design of some of the larger-scaled vehicles, such as space stations or large battleships.

GALACTIC IMPERIUM ORBITAL STATIONS
The orbital stations are constructed using the same technology as the smaller Galactic Imperium vehicles, but their service lifetime is much longer, as much as 20–30 years for some of the more remote systems. Like the smaller vehicles, the orbital stations are notable for their hard-edged, geometric forms, punctuated with smaller areas of irregular detail.

This composite 2D/3D illustration depicts the orbital station in its normal environment.

Like some of the spaceship designs, the overall form consists of large geometric primitives, with areas of concentrated detail.

ORBITAL STATION SKETCH

The Galactic Imperium governs and maintains control of the planetary systems with their huge orbital stations. These artificial satellites are almost like vast city-structures, and are capable of moving under their own power, although they are not very manoeuvrable and take quite a bit of time to accelerate. This concept sketch explores some of the geometry of an orbiting Galactic Imperium space station.

PLANETARY FEDERATION BASE

Because the Federation comprises a number of different worlds and cultures, the design of the environments and architecture can vary depending on the planet, moon, space station, or ring world. Although there are some exceptions, the building technology of the Federation is not as advanced as that of the Imperium; buildings and structures are often constructed using conventional building technology rather than through the use of nano-assemblers (see pages 118–119).

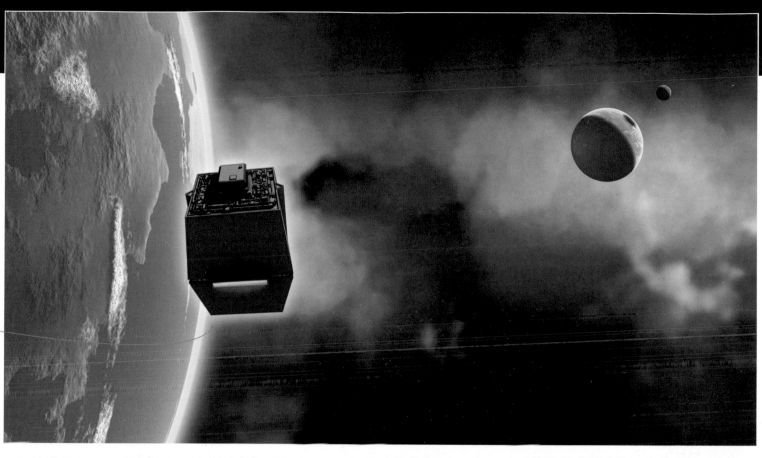
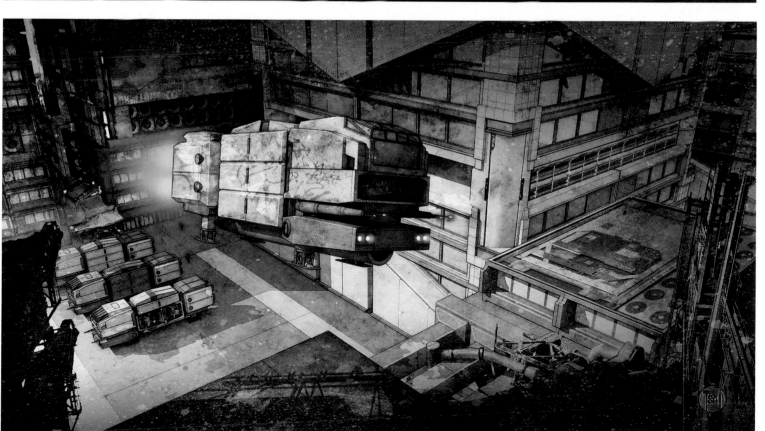

A single, key image can illustrate an important scene, establish a location or introduce major characters, but it can be difficult for an individual image to convey an entire storyline. Often the best option for creating an illustration is to pique the viewer's curiosity, to make him or her want to find out more about the story and the people involved.

To that end, the strategy for the final space-opera illustration will be to create a montage-style movie poster, showing some of the main characters and paying visual homage to the space-opera imagery of *Buck Rogers* and *Flash Gordon*. With this approach, the characters will take centre stage, but it is also important to establish the outer-space setting, a flavour of the technology (weapons and ships), and some sense of the central conflict in the story.

DESIGN IDEAS

The first step is to sketch some possible compositions for the final image, trying out different arrangements of the main characters. Because the image will be a montage, it is not necessary to make all the characters the same scale, or even inhabit the same scene. The triangular shape of Uvei Mortis' head is a useful graphic device for designing the composition. Most of the characters do not have a strong graphic silhouette like this, so it is definitely a shape to take advantage of in the poster design.

HORIZONTAL COMPOSITION

Movie posters generally have a vertical composition, but it can be worth exploring other options. Horizontally oriented compositions can present storytelling opportunities that are not as easy to accomplish with a vertical format. In this sketch, two of the Planetary Federation characters occupy the foreground, with Uvei Mortis looming in the background with some sort of establishing scene in the middle distance.

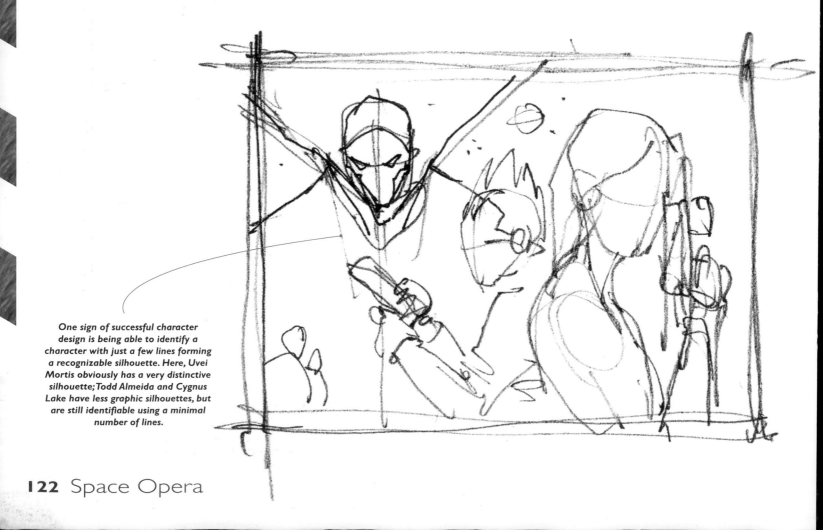

One sign of successful character design is being able to identify a character with just a few lines forming a recognizable silhouette. Here, Uvei Mortis obviously has a very distinctive silhouette; Todd Almeida and Cygnus Lake have less graphic silhouettes, but are still identifiable using a minimal number of lines.

SECONDARY POSTER OPTION

Uvei Mortis again appears in the background of this design, with his daughter Princess Tristan Mortis in the centre, and a fleet of ships racing towards the viewer. This composition could work well as a secondary poster featuring only characters and ships from the Galactic Imperium, perhaps paired with a similar poster featuring Planetary Federation ships and characters.

ALTERNATIVE LAYOUT

This design features a vertical composition with Uvei Mortis in the foreground. The graphic triangular shape of his head informs the composition more here, creating an interesting downward point at the bottom of the image. The other characters occupy the middle ground and an outer-space scene fills in the background. This is the most promising of the three designs, and the one that will be used for the final demonstration.

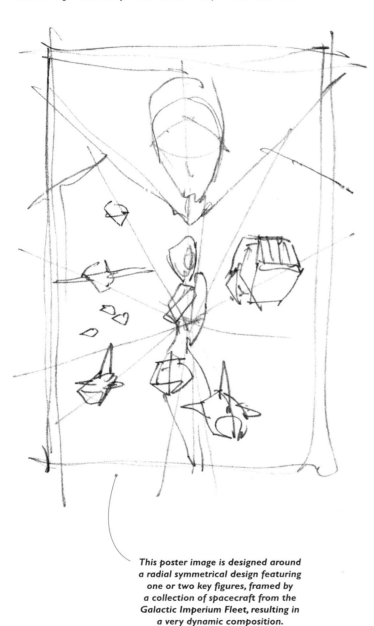

This poster image is designed around a radial symmetrical design featuring one or two key figures, framed by a collection of spacecraft from the Galactic Imperium Fleet, resulting in a very dynamic composition.

Because character interaction is arguably more important in a space opera than the vehicles and other technological accoutrements, an effective design should feature the cast of characters in a way that attracts the viewer's attention.

working up the final illustration

To create the final illustration, the movie poster that serves as an 'audience teaser' for the space-opera story, you will build on the thumbnail sketch chosen from the initial rough ideas shown on pages 122–123, working through rough value and colour compositions to a final full-colour painted image.

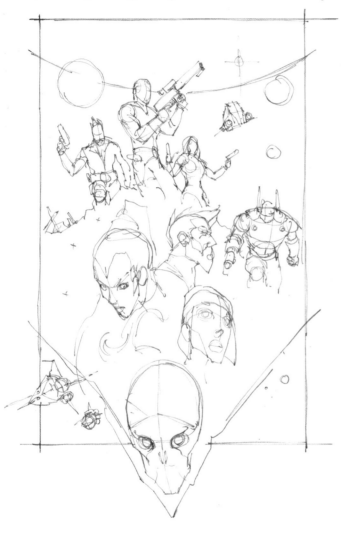

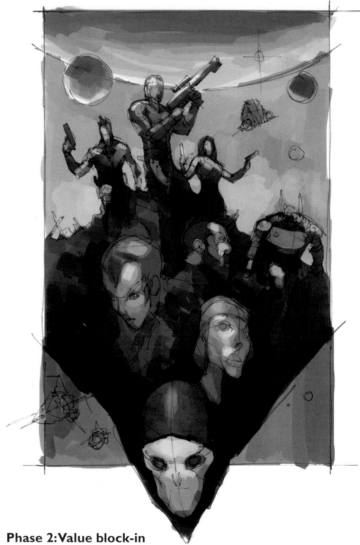

Phase 1: Image enlargement

First, the chosen thumbnail sketch needs to be enlarged to the size of the final art, which is approximately 43 x 28cm (17 x 11in). If you are working with traditional media, blow up the thumbnail sketch on a photocopier. If working digitally, scan the thumbnail sketch into the computer, enlarge it in your digital painting program and print it out at the larger size. The photocopy or printout serves as an underlay from which to create the larger line drawing. Trace the basic layout from the enlarged thumbnail sketch, taking the opportunity to correct any obvious scale, anatomical or perspective errors. It is fine to remain fairly sketchy at this point.

Phase 2: Value block-in

Using the newly traced line drawing, create a grayscale composition to determine the overall lighting and values in the image. Use a hard-edged brush to block in the basic values. For the foreground characters, use a light source directly overhead, which casts interesting highlights and shadows across their faces. The background characters can also be lit with overhead lighting, with backlighting coming from the space scene behind them. The backlighting will help their silhouettes read more easily and will provide opportunities to introduce complementary colour temperatures later. This study will help determine how much detail to include in the final line art.

Phase 3: Initial colour composition

Using the grayscale image from the previous phase as a value guide, design a basic colour composition consisting of an overall gradient of warm red-orange at the bottom to a cool blue-grey at the top. The previous grayscale phase set up a rhythm of alternating dark and light bands, with the characters' faces punctuating the dark areas with spots of lighter value. The colour gradient introduced in this phase uses colour temperature as another tool to increase contrast selectively at important areas, such as character faces and silhouettes. There will be some local variations in colour once you start working on the final painting, but this gradient serves as a good first step.

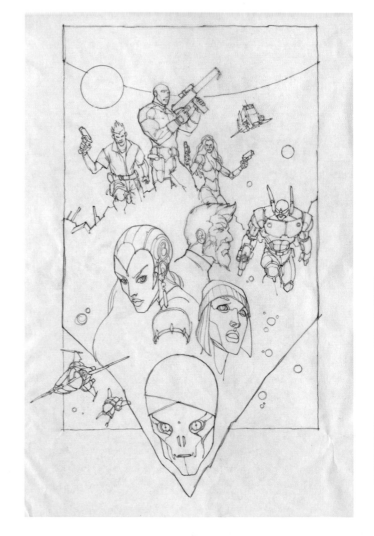

Phase 4: Line art

On a new piece of tracing paper, parchment or vellum, draw the final line art using the sketch from the very first phase as a guide. In this drawing, add the key details that differentiate the characters from each other and that give them some sense of personality – clothing details, seams and mechanical details on the robotic characters, and different facial expressions. In certain areas, such as the triangular shape silhouetting the characters' faces and the surface of the planet at the top of the image, detail and texture can be added later in the painting process.

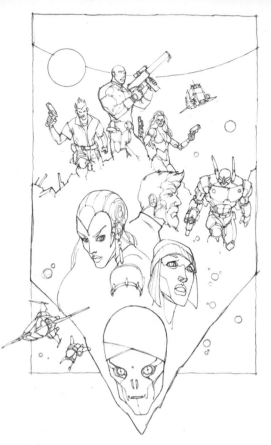

Phase 5: Preparation for painting

If working digitally, scan the line art from the previous phase into your preferred painting program and clean it up using the Levels tool to leave a crisp white background (see page 16). If you are working with traditional media, trace the line art on to your final media using a light box. If necessary, clean up the line drawing further with a kneaded eraser. Take a moment here to employ the trick of studying the image in a mirror (or temporarily flip the image horizontally in your digital painting program) to check for any drawing errors that you might have missed during the previous stages.

Phase 6: Grayscale base

Create a detailed grayscale value painting using a combination of hard-edged brushes and airbrushes, using the earlier grayscale value composition as a guide. Because of the collage nature of the piece, you are fairly free to adjust the lighting on individual characters without necessarily having to account for it on all of the other characters. For example, some drama can be added to the three-quarter view of Princess Tristan Mortis by suggesting a dimmer light source lighting the left side of her face.

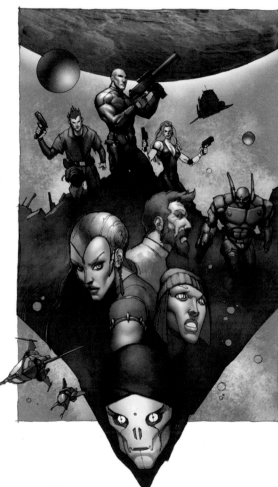

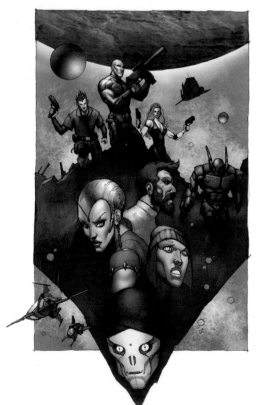

Phase 7: Colour application

Once the grayscale value painting has been completed to your satisfaction, begin adding the colours on top. The colours should be applied in a transparent way, so that the values established by the grayscale painting are retained. Refer to the colour composition from Phase 3 in order to maintain the general colour design. In the darker areas it may be difficult to significantly affect the colour; don't worry about it too much at this stage, as colour can be added in a more opaque manner once the initial colour pass is completed.

Phase 8: Final image

Continue refining the rendering of the various components, referring to the earlier stages periodically to remind yourself of the initial strategy. Work from large to small, using large brushstrokes to begin with and gradually working down to details. In areas that were too dark for the transparent washes to affect the colour, paint with opaque colours to exert more control over the darker values. Although the majority of the colour, value and composition decisions were made in the earlier planning stages, the labour of actually executing the final painting happens in this final stage. Once the cast of characters is rendered, a final layer of 'flavour' can be added by overlaying some high-tech symbols and graphics (the various digital readouts and diagrams seen in light aqua-blue). These final elements help bridge the gap between the classic space opera of the movie-serial era and the present 21st century.

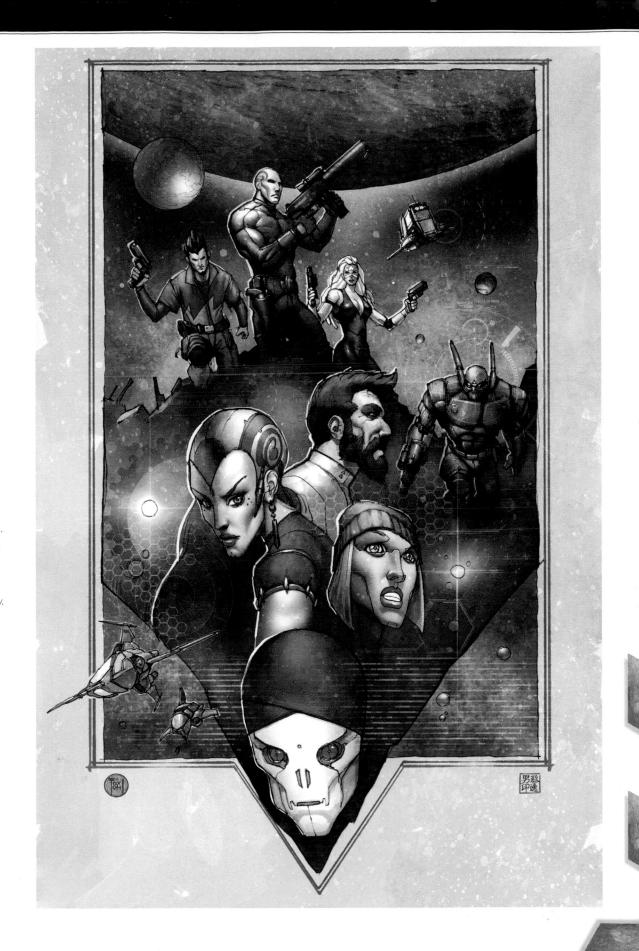

index

ABOUT THE AUTHOR

Francis Tsai is a well-known illustrator and conceptual designer from San Diego, USA. He has provided design work for video-game projects such as *Tomb Raider Anniversary, Star Trek: Hidden Evil, The Bourne Conspiracy, Darkwatch* and *Myst III: Exile*, as well as conceptual design work for television commercials and films such as Warner Brothers' computer-animated film *Teenage Mutant Ninja Turtles*. Francis' illustration work can be found in magazines, role-playing game manuals and trading cards from publishers such as Upper Deck, Paizo Publishing and Wizards of the Coast, and in comic books and graphic novels from Marvel, Top Cow, Dark Horse, Dabel Brothers and Devil's Due Publishing. Francis' work has won awards from The Society of Illustrators and can be seen in high-end art annuals such as *Spectrum Fantastic Art* and *Exposé*. He has written extensively for *ImagineFX* magazine, and is the author of *100 Ways to Create Fantasy Figures*, also published by David & Charles.